Chinese Calligraphy | Cultural China Series

© Cultural China Series

Chinese Calligraphy

Chen Tingyou

Translated by Ren Lingjuan

CHINA
INTERCONTINENTAL
PRESS

图书在版编目（CIP）数据

中国书法／陈廷祐著；任灵娟译 . —北京：五洲传播出版社，
2003.12

ISBN 7-5085-0322-8

I.中 ... II.①陈 ... ②任 ... III.汉字—书法—研究—英
文 IV.J292.1

中国版本图书馆 CIP 数据核字（2003）第 090744 号

中国书法

著　　者／陈廷祐

译　　者／任灵娟

责任编辑／邓锦辉

整体设计／海　洋

出版发行／五洲传播出版社（北京北三环中路31号　邮编:100088）

设计制作／北京锦绣东方图文设计有限公司

承 印 者／北京华联印刷有限公司

开　　本／720×965 毫米　1/16

字　　数／95 千字

印　　张／8.5

版　　次／2003 年 12 月第 1 版

印　　次／2003 年 12 月第 1 次印刷

书　　号／ISBN 7-5085-0322-8/J·261

定　　价／56.00 元

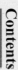

Contents

1

Calligraphy:
A Cultural Treasure of China

Calligraphy is the quintessence of Chinese culture. There have emerged some 1,000 kinds of written languages in the world. First, they were used to record events and what people wanted to say. In writing, people strive to make the scripts look beautiful and elegant. To meet special needs, they are written in artistic styles. The writing of Chinese characters has been developed into a special high-level art. Chinese calligraphy has flourished for several thousand years. Like painting, sculpture, poetry, music, dance and opera, it is a full member of the family of arts.

Calligraphy can be found everywhere in China, and is closely linked to daily life. In addition, it leads other arts in the number of people who practice it.

Signboards with inscriptions by famous figures are often found in shops and shopping centers, adding an antique elegance to busy and noisy trading areas.

Calligraphic works also decorate sitting rooms, studies and bedrooms. The Chinese characters are written on Xuan paper which is good at absorbing ink. The work will be

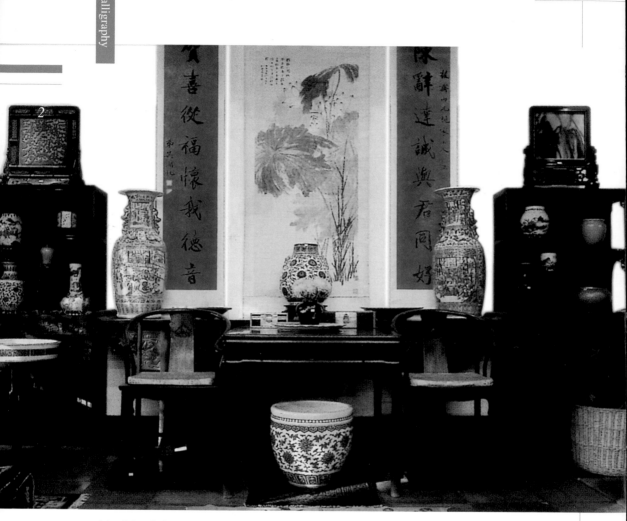

A traditional sitting room
of a scholar.

pasted on a piece of thick paper with a silk edge, and then
mounted on a scroll or put into a picture frame for hanging
on a wall. Usually, the calligraphic work contains a poem,
a pair of couplets or a motto the host likes very much. If
the calligraphic work is written by the host himself, it will
demonstrates his aspiration and interest as well as his
literary or artistic talent. A calligraphic work can bring

vitality to a white wall, pleasing to guests and friends.

Spring Festival couplets are calligraphic works produced specially for the celebration of the Spring Festival, the most important traditional festival of the Chinese people. Written on red paper, such couplets are posted on gateposts, door panels, walls or columns of houses. The characters on the couplets always express good wishes for the year.

A running-style calligraphic work by Pan Boying on a fan covering.

Characters in special styles appear as masthead inscriptions for newspapers or magazines, or as the titles of books. The six characters meaning the People's Bank of China on Chinese banknotes were written by a famous calligrapher. The calligraphic characters or paintings on folded fans demonstrate the elegance of the user. It is no exaggeration to say that the Chinese people have an indissoluble bond with calligraphy. The first photo album of a newborn baby has congratulations written by his elders with brush and ink; when he gets married, the pillow cases are embroidered with the

A pair of Spring Festival couplets and New Year pictures on the main gate of a house.

"double happiness" symbol in calligraphic style; on his birthday, a big character meaning "longevity" in a calligraphic style is hung up in the house. After his death, the inscription on the memorial tablet in front of his tomb is written by a calligrapher.

Tourists can see calligraphic works in pavilions, towers and buildings in various scenic spots. Such calligraphic

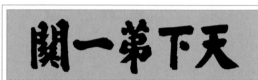

The gate-tower of the Shanhai Pass and the horizontal plaque.

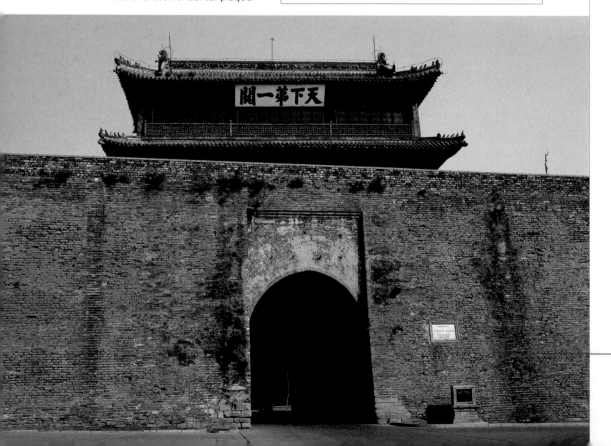

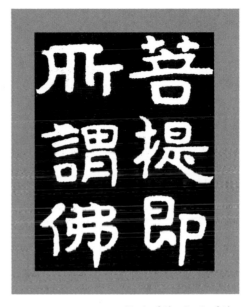

inscriptions on wooden boards or rocks integrate harmoniously with the surrounding scenery, and add radiance and beauty to it. The gate-tower of the Shanhai Pass at the eastern end of the Great Wall, 300 kilometers away from Beijing, was built in 1381. From the tower, tourists can have a bird's-eye view of the sea and magnificent mountains. Under the eaves of the gate-tower is a horizontal plaque inscribed with five huge Chinese characters meaning "The First Pass Under Heaven." They were written by the famous calligrapher Xiao Xian of the Ming Dynasty (1368-1644). The plaque matches the magnificent scenery around.

Part of the text of the Buddhist Diamond Sutra in the Sutra Stone Valley.

If you visit Mount Taishan in Shandong Province, you can visit the Sutra Stone Valley to the east of Longquan Peak, where, on a flat 6,000-square-meter rock, a calligrapher carved the text of the Buddhist Diamond Sutra in the sixth century, each character measuring 35 square centimeters, and the largest one measuring 50 square centimeters. However, only 1,067 of the 3,017 original characters are legible.

In Shaoxing, Zhejiang Province, your guide will take you to visit the Orchid Pavilion, a Mecca for calligraphers in China. On a spring day in 353, Wang Xizhi, who later became one of China's most distinguished calligraphers, and 40 other men of letters gathered at the Orchid Pavilion to

列坐其次雖無絲竹管弦之
盛一觴一詠亦足以暢叙幽情
是日也天朗氣清惠風和暢仰
觀宇宙之大俯察品類之盛
所以遊目騁懷足以極視聽之
娛信可樂也夫人之相與俯仰

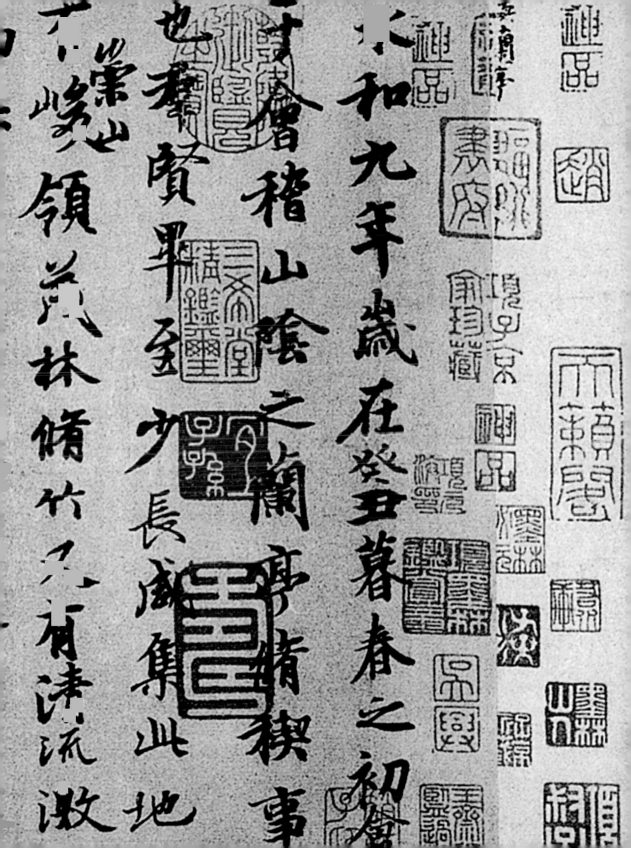

永和九年歲在癸丑暮春之初會
于會稽山陰之蘭亭修禊事
也群賢畢至少長咸集此地
有崇山峻領茂林修竹又有清流激

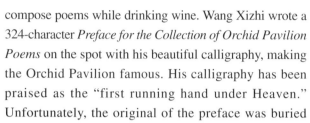

Preface for the "Collection of Orchid Pavilion Poems" written by Wang Xizhi of the Jin Dynasty.

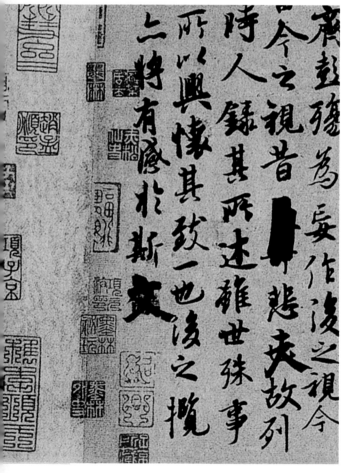

compose poems while drinking wine. Wang Xizhi wrote a 324-character *Preface for the Collection of Orchid Pavilion Poems* on the spot with his beautiful calligraphy, making the Orchid Pavilion famous. His calligraphy has been praised as the "first running hand under Heaven." Unfortunately, the original of the preface was buried together with Li Shimin, the second emperor of the Tang Dynasty, who was also a fine calligrapher. The preface we see today is a copy done by Feng Chengsu of the Tang Dynasty.

The Forest of Steles in the ancient capital city of Xi'an is the oldest and best collection in China and a treasure house of ancient Chinese calligraphy, art, classics and stone engraving. More than 2,000 inscribed tablets and memorial tablets from tombs and pavilions of the Han and Tang dynasties are displayed in exhibition halls, galleries and pavilions. First built in 1087, the Forest of Steles is a part of the Shaanxi Provincial Museum, and a cultural site under state protection.

There are rigorous standards and criteria for assessing calligraphic skills and works. The calligraphic

A picture of Lu Xun (1881-1936), a great writer of china.

A running-script letter by Lu Xun.

skills demonstrate the cultural background, artistic level and sentiments of the calligrapher. Through the ages, many of famous calligraphers have been painters, thinkers, politicians or scholars too. When talking about a person's achievements in calligraphy, his achievements in other fields are always mentioned. Excellent calligraphic works are held to demonstrate outstanding ability and great learning.

Calligraphy is the first artistic endeavor the Chinese people learn. While teaching children to read characters, parents and teachers not only show them the strokes, they also try to arouse their aesthetic consciousness and develop their artistic judgment and creation. This is helpful for their future lives.

People call calligraphy "painting without images, a piece of music without sounds, a stage without actors and actresses and a building without components and materials." Calligraphic works express various essential factors of beauty – balance, proportion, variety, continuity, contrast, movement, change and harmony – through the different shapes and forms of the lines, their combinations and ways of movement. Calligraphy has also inspired other arts, and vice versa.

Like music, calligraphy has rhythm as its main element. The dots and strokes in thick and light ink or in round or square shapes demonstrate obvious rhythms, like changing and moving musical rhythms, expressing the surging thoughts and emotions of the calligrapher and musician alike. It is no wonder that

calligraphy theorists praise calligraphic works as being like "music in the air" or as "a wonderful piece of music played by an excellent musician."

Also, calligraphic works can demonstrate the beauty of both the body and movement, like the art of dance. Both have artistic features concerning the space and time. Calligraphy and dance can absorb inspiration from each other. Zhang Xu, a cursive-script calligraphy master of the Tang Dynasty, was famous for distinctive rhythms and a

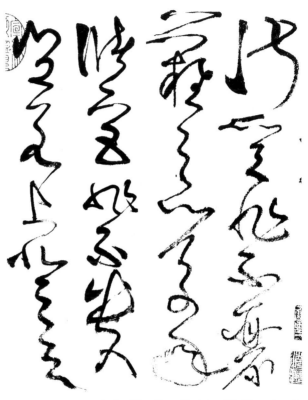

Part of the *Four Models of Calligraphy of Classical Poems*, by Zhang Xu.

wild style. Legend says that he made swift progress in his calligraphy after he got inspiration from a dance performed by the famous dancer Gongsun. Through distinctive rhythms and neat movements, the dancer demonstrates various kinds of charms and emotions such as vividness, joy, sadness, anger, aspiration, demand, boldness and inspiration. The cursive-script calligraphic works by Zhang Xu, the poems by Li Bai and the sword dance by Pei Min were praised as three wonders by the emperor of their time. The *Four Models of Calligraphy of Classical Poems* is one of the few calligraphic works by Zhang Xu handed down by history. The

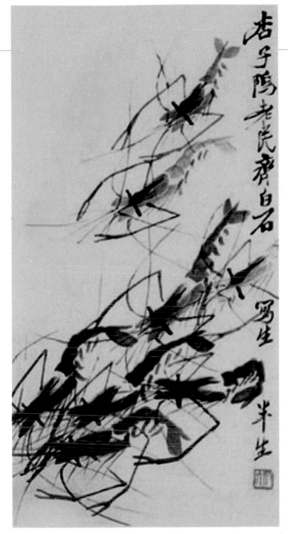

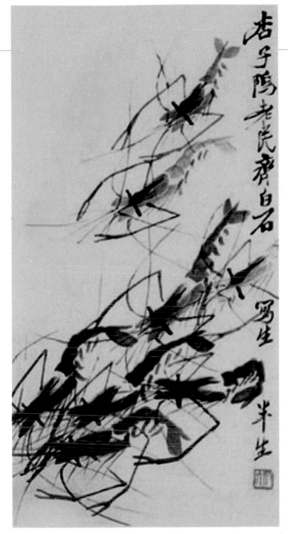

A wash painting, *Shrimps*, by Qi Baishi.

characters used in this work are bold and unrestrained, and linked together like one character. The space between the characters varies greatly.

In the 1980s, a television station in Beijing broadcast an artistic program entitled "Ink Dance," which demonstrated the arts of calligraphy and dance at the same time. With the background of a calligraphic work, the dancer presented the dance movements according to the meanings and shapes of the characters. The light steps, soft waist movements and gentle music stimulated the audience's imagination.

Calligraphy has an even closer relation with traditional Chinese painting. Both use brushes and Xuan paper; the difference is that the former uses black ink only, while the latter uses various kinds of colors. Calligraphy, as a kind of art, exists together with the other arts. In bookstores, calligraphic works are sold together with paintings. At some exhibitions, calligraphic works are on display together with paintings. Usually, a painter leaves some space for a calligrapher to write a classical poem or poetic

lines related to the scenes and objects appearing on the picture in order to increase its attraction. The picture will be more charming and tasteful if it bears a poem created and written by the painter himself or herself. In the past, an artist who was good at poetry, calligraphy and painting was called a "person with three wonderful talents." Since the Tang Dynasty, each historical period has produced many such talented people.

Calligraphy and painting have many skills to exchange. Traditional painting has drawn inspiration from calligraphy in using brush and ink, especially in the field of abstract implications and freeing itself from shackles of concrete objects. Chinese wash painting originated in the simple but smooth brush strokes of calligraphy. Qi Baishi's paintings of shrimps are good examples of such wash paintings. Qi sketches shrimps with a few simple strokes, using different shades of ink. Without any concrete depiction of water, people can visualize the murmuring stream, and smell the refreshing fragrance of water.

The guiding and leading position of calligraphy with regard to various kinds of arts is like that of the mathematics among the various natural sciences, such as physics, chemistry, geology and meteorology. In general, mathematical theory is abstract but profoundly reflects the relations between space and mathematics. So all schools have paid great attention to education in mathematics, and natural scientists have relied on sound mathematical knowledge to study the profound mysteries and master the principles of the natural sciences they are engaged in. Talking about this reminds me of a celebrated dictum of Lao Zi, the great Taoist philosopher who lived 2,500 years ago: "The Tao (Way) is mysterious and profound, and is the door to various wonders." Here I apply his dictum to Chinese calligraphy, which I see as mysterious and profound, and is the door to various kinds of arts.

Unique Chinese Characters

All written languages have three key elements or functions: shape, pronunciation, and meaning. With regard to Chinese calligraphy, the shape of the characters is closely related to it; the meanings of the characters have some, but not a great relationship with it; and the pronunciation of the characters has no relationship with it at all. So I will mainly introduce the relations of the unique shapes of the Chinese characters to the art of calligraphy.

The special and unique shapes of the Chinese characters and the principle of their composition form the basis of the emergence and development of Chinese calligraphy. Like astronomical phenomena, among numerous stars in the universe only the earth has water and air; here, all living things, especially human beings, can survive and reproduce. For calligraphy, the unique Chinese characters are its water and air.

Chinese characters are square, and each occupies a square space on paper. Statistics show that there are 3,500 common characters, against the total of 90,000. The Chinese people use these characters, which occupy a similar space each but with different shapes, as means to

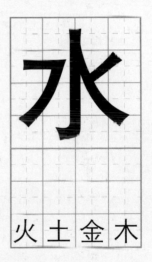

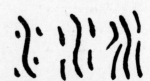

The special forms and composition of Chinese characters. Chinese characters occupy a square space each.

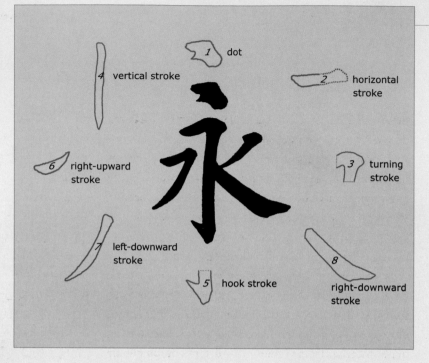

The character "yong" demonstrates the eight fundamental strokes. The numbers in the two pictures above show the writing order of the strokes.

exchange or record information. You can imagine how many wonderful arrangements are needed for the creation of Chinese characters of thousands of different shapes to fit in a small square.

Chinese characters, in general, are composed of a dozen basic strokes, which have similar functions to the letters of the Western languages. But they do not combine sounds into syllables. There are eight basic strokes: dot, horizontal stroke, turning stroke, vertical stroke, hook stroke, right-upward stroke, left-downward stroke and right-downward stroke. They can be demonstrated using the character "永" (yong) in the so-called formal script.

In practice, in individual handwriting, the strokes show some variations, as they do in different styles of script. Take the formal script for example. A dot in the formal script is written in

more than 20 different ways, and the hook stroke in a dozen different ways. Some are illustrated on this page. In a small square space, characters are composed of different strokes linked and arranged in various ways, thus they are easily to recognize, and look neat. These strokes are placed in various positions in the square – upper or lower, left or right, separate or linked, crossed, going through, overlapping, piling up or surrounding.

Western languages have 20-30 letters, more than the basic strokes of Chinese characters, but have only three forms: straight line, curved line and dot. And the letters, disregarding their numbers, are arranged from left to right, quite different from Chinese characters, which can be arranged in order, irregular, close and loose ways according to the varied compositions of their strokes.

In general, there are two or three handwriting styles like formal and cursive scripts in the world, much fewer than the dozen scripts in Chinese calligraphy. Here I introduce five scripts. The first three are commonly used, while the other two are archaic and only used in calligraphy nowadays.

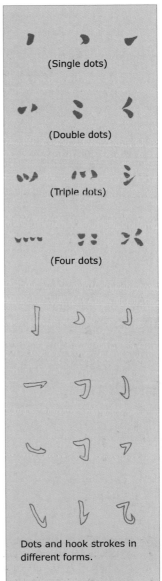

(Single dots)

(Double dots)

(Triple dots)

(Four dots)

Dots and hook strokes in different forms.

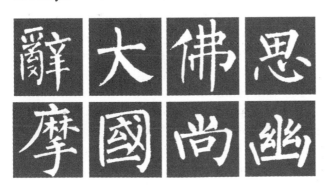

Characters are composed of strokes arranged in different ways.

Formal script, or regular style. With a history of more than 1,000 years, formal script is a fundamental writing style and usually appears in printed matter and on computer screens, featuring standard strokes, rigorous rules and a slow speed of writing. The Chinese characters in this style are easy to recognize. This style is commonly used in shop signs, horizontal or vertical signboards on buildings, Spring Festival couplets, tablets in front of tombs, monuments, nameplates of newspapers and official documents and correspondence.

Running script. This script has been developed from the quick-writing formal script, and is a style halfway between formal script and cursive script. Such a style is looser than the formal script, and has more links between strokes. Most characters in this style have slanting shapes. Moving of the strokes is simple, smooth and light, and characters are easily recognizable. This writing style appears usually in letters and daily life writing.

Cursive script. Written at the quickest speed, the characters in this style are further away from the formal script than the running script in form. With irregular forms, some strokes join together, or parts of strokes or some whole strokes are omitted. So the characters in this style are difficult

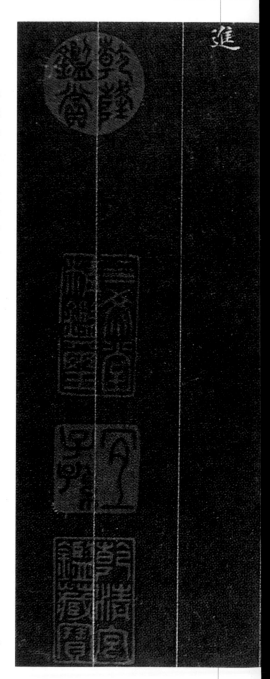

Part of the formal-script *Buddhist Sutra* by Liu Yong (1720-1805).

忍若為生他善根若少讀誦已而能為他多

說法義當得不斷辯才佛說此經時文殊

師利童子及餘菩薩摩訶薩上座舍利弗

及餘諸比丘并諸天眾犍闥婆人阿修羅

等聞佛所說皆大歡喜

入法界體性經

劉墉敬書恭

筆盡懷傳雙鳳

安丘況五龍家笛句

國戲笛國戲笛笋点于

作花弟頹一般侄屋

曉視手教琵琶詩安

國抱崢暮八月歌

樣

正

奉畜詩所畫面曲張

遮士而以府方可之外龙細

為乃致也附

Square scroll in running hand by Bada Shanren (1626?-1705).

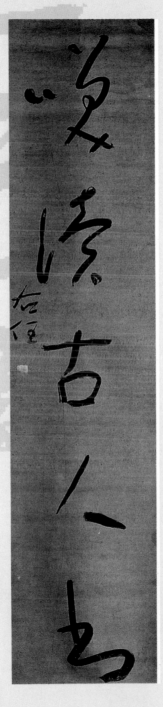

A pair of couplets in running script by Yu Youren (1879-1964).

破屋士贈元康
塘研試墨
丙辰冬仲 吳昌碩

此數字學者易入板滯
尚易堕宫齋集
丙辰長夏 吳昌碩老缶

to write and recognize.

Seal script. The most ancient calligraphic style, the seal script is no longer used except for special effects. The ancient seal-script characters were discovered in inscriptions carved on oracle bones, which were animal bones and tortoise shells used for divination, and on ancient bronze objects as well as in lesser-seal-style inscriptions. It contains few strokes and no dots, hooks or turning strokes, and seeks a unanimous thickness of lines, symmetry and balanced distribution of strokes. Although people nowadays find them very difficult to recognize, they are full of mystery and charm. A piece of seal-script calligraphic work makes the people understand the simple and honest hearts of their earliest artists and inspires high praise for China's ancient culture.

Official script. This basic form appeared after the seal script, and was mainly used during the Han Dynasty.

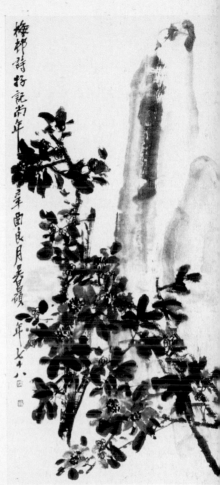

Camellia by Wu Changshuo (1844-1927).

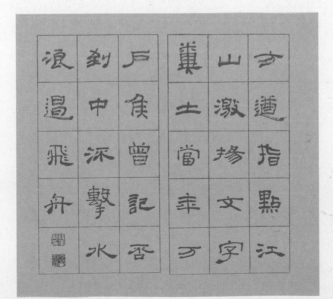

Pages from the *Book of Models* of official-script calligraphy by Qian Shoutie (1897-1967).

It changed the rule of unanimous thickness of strokes in the seal script and abolished the pictographic features of the seal script. The characters of this script are squat-shaped, contrasted with the high shapes of the other five scripts. The official-script characters are antique, but easy to recognize.

Today, characters appearing in print and used in computers are mainly Song, imitation-Song, block and boldface characters. The Song style was developed when movable type printing was invented in the Song Dynasty, represented by the calligraphic works of Ouyang Xun and his son Ouyang Tong from the Tang Dynasty. It was reformed during the Ming Dynasty, having thicker vertical strokes and thinner horizontal strokes, and has been the main printing style since the 16th century. The imitation-Song style changed all strokes into thin ones. The block style is a printing style very similar to the handwriting style. Recently, some other block characters have appeared in print and in computer formats, including the Shu style, represented by the modern calligrapher Shu Tong (1906-1998).

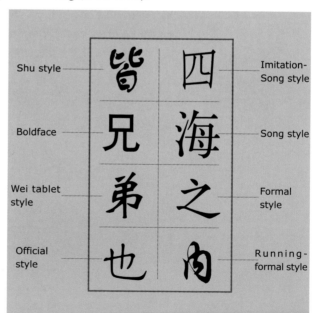

Shu style — 皆
Boldface — 兄
Wei tablet style — 弟
Official style — 也

Imitation-Song style — 四
Song style — 海
Formal style — 之
Running-formal style — 肉

Commonly used styles for prints and computer scripts include the Song, imitation-Song, formal, running-formal, Shu, boldface, Wei tablet and official styles.

Oracle Bone Inscriptions and Inscriptions on Ancient Bronze Objects

It is difficult to ascertain exactly how old Chinese characters are. The geometric designs on the 5,000 7,000-year-old pottery of the Yangshao culture discovered at Yangshao Village in the 1920s may be the embryo of Chinese characters. The following 2,000-3,000 years is a blank period for the development of Chinese characters and no cultural relics from this period have been discovered with traces of writing on them.

The oracle bone inscriptions and inscriptions on ancient bronze objects developed more than 3,000 years ago during the Shang Dynasty are the earliest systematized Chinese characters.

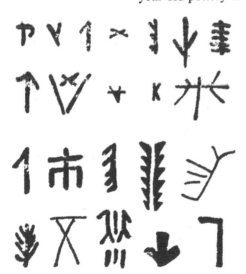

Designs on ancient pottery.

Picture of Cang Jie.

Oracle bone inscriptions. Divinations and supplications to the gods and the replies received inscribed on animal bones and tortoise shells are the earliest written characters so far discovered.

In the autumn of 1899, Wang Yirong, a Beijing official, fell ill with malaria. The imperial doctor wrote out a prescription for him. One of the medicinal ingredients was called a "dragon bone." He purchased the medicine from a drugstore, and was intrigued to find that there were some markings on the piece of bone, which looked like ancient

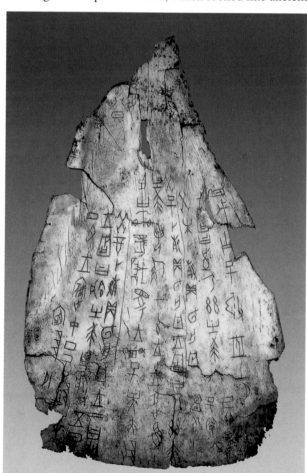

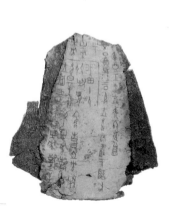

Inscriptions on oracle shells.

forms of Chinese characters. He bought more "dragon bones," and consulted his friend Liu E, who was an expert in the ancient Chinese script, who agreed that the markings were probably ancient characters. Later, Wang traced the origin of the bones to Xiaotun Village, northwest of Anyang, Henan Province and entrusted a businessman to buy more "dragon bones" directly from the village. The village is the location of the last capital of the Shang Dynasty.

If Wang had not fallen ill, if he had not been well versed in the ancient Chinese language, and if the imperial doctor had not written out a prescription for him including "dragon bones," these antique characters which are of such great importance for research into the origin of Chinese civilization might never have been discovered.

Wang Yirong was not only an upright and honest official of the Qing Dynasty, he was once governor of Shanxi Province and also a great patriot. When the Sino-Japanese War broke in 1894, he asked the emperor to let him go back to his native home

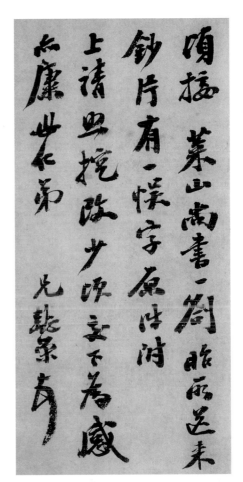

A short note written by Wang Yirong.

26

in Shandong, and raise a militia to resist the invaders. But the Qing government concluded a treaty in 1895 with the Japanese invaders, which humiliated the country and made it forfeit its sovereignty. In August 1900, when the allied forces of eight powers invaded Beijing, Wang was appointed minister in charge of training the armed forces in the metropolitan area. When Beijing fell to the invaders, Wang wrote his last words in formal script, stating his loyalty to the emperor, and then he, together with his wife and elder daughter-in-law, drowned himself in a well.

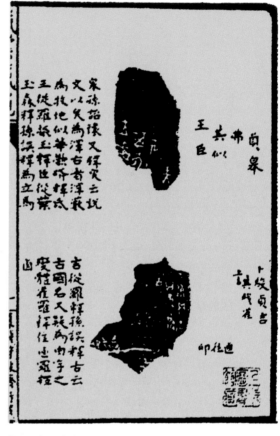

Some inscriptions on tortoise shells illustrated on Liu E's book *Tortoise Shells Preserved by Tie Yun.*

This happened less than one year after he found the oracle bone inscriptions, and he did not leave any records about his research into the oracle bone inscriptions.

The earliest book about the research and interpretation of the oracle bone inscriptions was written by Liu E, another discoverer of such inscriptions. In 1903, Liu E published his book *Tortoise Shells Preserved by Tie Yun.* In this book he identifies more than 40 characters on some 3,000 pieces of tortoise shells he collected. Later,

somebody corroborated his interpretations of 34 of them. Liu proved that these characters were of the same historical period as the inscriptions on bronze Shang Dynasty objects.

Oracle bone inscriptions were approximately used in the same period with the Egyptian hieroglyphics, the Mayan script of Central America and the Sumerian cuneiform characters. However, only the Chinese characters are the direct ancestors of the modern script.

Among some 4,700 characters appearing on the 100,000 pieces of tortoise shells discovered so far, some 1,800 have been identified. These inscriptions have yielded a great deal of information about the political system, agriculture, animal husbandry, astronomical phenomena, warfare, and

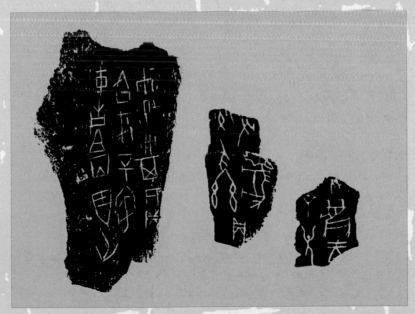

Some inscriptions on tortoise shells illustrated on Liu E's book *Tortoise Shells Preserved by Tie Yun*.

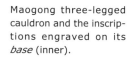

other aspects of the Shang period. They are also valuable materials for the study of calligraphy.

Like the characters of various scripts developed later, the characters on the tortoise shells occupy a square space each, basically engraved from top to bottom and with the lines from right to left, the same way as they have been written in the more than 3,000 years since then. It is clear, also, that the engravers of such inscriptions had an eye for symmetry and beauty.

Maogong three-legged cauldron and the inscriptions engraved on its *base* (inner).

Inscriptions on bronze objects. Bronze objects include cooking utensils, wine sets, water containers, weaponry, musical instruments and mirrors. The inscriptions run from one or two characters to several hundred. Some 3,000 different characters appear on bronze objects, 2,000 of which have been interpreted. The characters on bronze wares are more standard, regular and orderly than those on bones and tortoise shells.

During the Warring States Period (475-221 B.C.) of the late Zhou Dynasty, many of the states ruled by dukes or princes simplified the strokes of seal-script characters in their own way, and developed various kinds of "big-seal" styles, different from the lesser-seal style mentioned below.

When Qin Shihuang of the State of Qin united China for the first time, under the Qin Dynasty (221-206 B.C.), among the reforms he enacted was standardization of the various scripts, based on the characters used in Qin, later known as the "lesser-seal-style", which have a simplify quality. As in the big-seal style, the lesser-seal-style strokes have the same thickness, and there is no difference between right-upward strokes and left-downward strokes. But the strokes are more even and symmetrical than that in the big-seal hand.

The initiator of the use of the lesser-seal hand was Li Si (?-208 B.C.), a prime minister of Qin and the first calligrapher in recorded Chinese history. His calligraphic works are powerful and vigorous, and appreciated as models of the lesser-seal hand. A famous example of Li Si's calligraphy can be found in Andai Temple at the foot

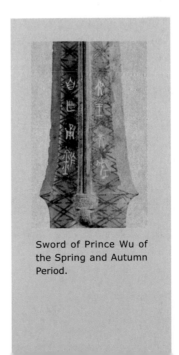

Sword of Prince Wu of the Spring and Autumn Period.

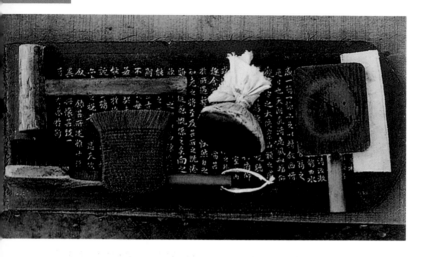

Rubbing tools on a rubbing of a calligraphic work, which demonstrates characters in white against a black background.

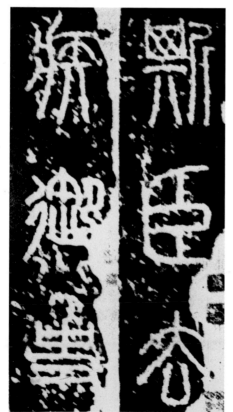

Taishan Mountain Inscription in the seal script by Li Si.

of Taishan Mountain in Shandong Province. Originally, there were more than 200 characters inscribed on a tablet erected at the top of the mountain, but only nine can be read today. The picture on the top shows a rubbing of the remaining part of the tablet. Such rubbings are made by covering inscriptions on stone or bronze with a piece of moist paper and pressing an ink-soaked silk wad stuffed with cotton. In this way, the characters stand out in white against the black ink background. Many illustrations in this book are rubbings from original inscriptions.

Official Script and Later Scripts

In the Qin Dynasty, there were busy exchanges of documents between the central and local governments and cultural and information exchanges between various parts of the country were speeded up. These exchanges demanded the swift writing of documents and notices, with little attention to the nice forms of the characters or the length and thickness of strokes. Also, people believed changeable, vigorous and not well-proportioned characters were nicer than those in even and symmetrical forms, and with unified strokes. As a result, the cursive and cursive-seal hands appeared.

The cursive-seal hand is quite different from the

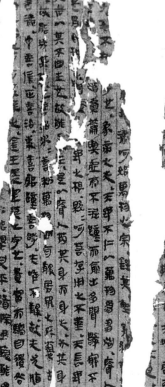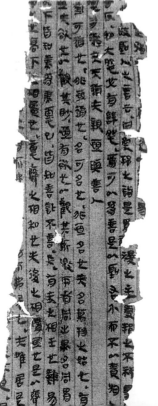

Ancient official-script characters written on silk.

常者罷初可匈人　上廣對鄉史振未辟廣對賀衣偃史前鄉

東爾履盡萬民　老壹蒙主社棄諸

下不敗重父母所致也郡國易然臣廣顏歸主杖沒入為官臣廣昧死再拜敢問

陛八

朗何鄉吏論棄市女須時廣覺毛杖如故

二　　　　　　　元　三年　月壬申下

街文書十以上杖王杖比六百石入官府不趨吏民有敺辱者逆不道

棄市令左蘭屋　卅二

汜南郡男子王安世坐殺點毆鳩杖主折傷毆王杖棄市南郡亭

司馬護坐檀召鳩杖主擊留棄市長　免東鄉嗇夫田宣

鳩杖王男子金里告之棄市隴西男子張湯坐桀點毆棄里主擊天田宣

里杖棄市亭長二人鄉嗇二人自衣民三人皆坐殿毆棄王杖

左王丈　　　　晉人

< Ancient official-script characters on bamboo strips from the Han Dynasty, discovered in Wuwei, Gansu Province, in 1959.

Official Script and Later Scripts

33

cursive hand and official hand, and even the lesser-seal hand. Later, it demonstrated more features of the standard official hand and was called the ancient official hand.

In the process of disintegration of the seal hand, the rule of the same thickness and length of strokes was broken by more and more calligraphers. Some intentionally extended the vertical strokes and hook strokes, or exaggerated right-downward strokes. Some even tried to write characters in a new way: starting the single horizontal stroke or the last of two or three horizontal strokes with a depiction of a silkworm's head and ending in a wild goose's tail. Such a style was followed by many calligraphers gradually, and finally developed into the official script, different from the ancient official script. The inscription on the "Shichen Tablet" is a typical example of such a hand. The official hand was developed in the Eastern

Part of the *Shichen Tablet*, carved in 169, Eastern Han Dynasty.

Han Dynasty (c. first century) and is the second-generation basic calligraphic style to evolve after the seal style.

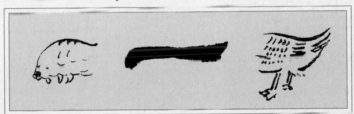

A horizontal stroke in the official hand starts with a "silkworm head" and ends in a "wild goose tail."

The evolution from the seal hand and ancient official style to official hand was a mystery until the turn of the 20th century. The 2,000-3,000-year interval between pictographs and inscriptions on tortoise shells and bronze objects used to be a blank in the history of the development of Chinese writing.

Then in the 1890s and 1900s, inscriptions on a total of 100,000 bamboo or wooden strips 20-30 cm long and 1-5

34

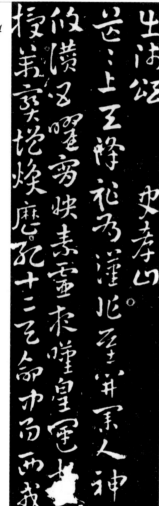

Part of *Ode on Sending Out the Troops* in "zhang cao" cursive script.

cm wide dating from the Qin and Han dynasties were discovered in Xinjiang, Inner Mongolia, Gansu, Qinghai, Hunan, Hubei, Shandong and Henan. The inscriptions are in the ancient official style, different from the official style of the Eastern Han Dynasty found on stone steles. They proved to be a transitional form of writing between the seal and official styles.

After the official style, calligraphers sought a simpler and more elegant style, discarding horizontal strokes starting with a silkworm's head and ending with a wild goose's tail, and created the cursive style. Simple and smooth, the strokes of the characters written in the cursive hand are not linked but remain separate. This style is called the "zhang cao" cursive script, and was in fashion in the third and fourth centuries. But not too many people know it.

Following the "zhang cao" cursive script, a "modern" cursive hand appeared. But the latter was not developed from the "zhang cao" cursive script, but from the ancient official style. Characters in the former cursive style are independent, while those of the latter are usually linked together.

The running hand is another script which developed after the official hand, and was commonly used in letters and documents. It is easy to recognize, and simple, and flexible to use. In the process of its development, it absorbed elements of the formal and cursive styles.

As these new calligraphic styles developed, the formal script appeared too. People found it troublesome to follow the way of starting a horizontal stroke with a silkworm's head and ending it in a wild goose's tail and thick right-

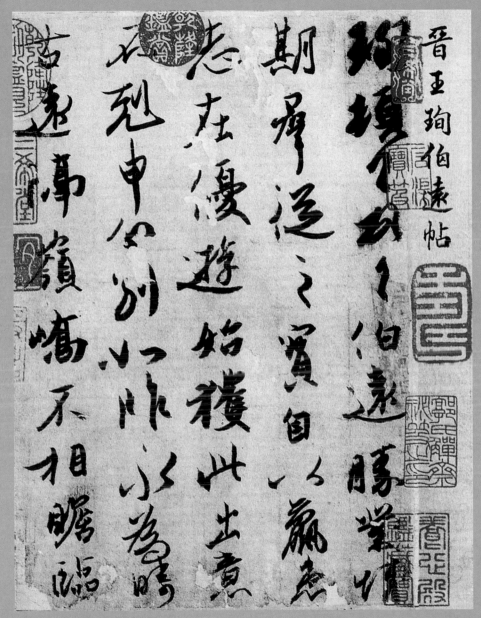

Baiyuan Scroll in the running-cursive hand, written by Wang Xun of the Jin Dynasty. Wang Xun (350-401) was director of the imperial secretariat and a distant relation of Wang Xizhi. He was famous for his essays and calligraphic works, and was acclaimed for his mastery of the cursive script. This calligraphic model has 47 characters. Together with the *Short Note of a Sunny Day After a Pleasant Snow* by Wang Xizhi (p. 96) and *Mid-Autumn scroll* by Wang Xianzhi (p. 55), it was listed as one of the three rare calligraphic models kept in the Sanxi Room by the Qing Emperor Qianlong.

downward stroke on bamboo or wooden strips. So they adopted some strokes from the cursive hand, to develop the formal hand. Initiated in the Han Dynasty, the formal hand came to be commonly used in the early Tang Dynasty (618-907). It became a new basic calligraphic style of the third generation used for the following 1,300 years.

From the official and other new styles mentioned above, some other styles were developed, such as the running-cursive hand, the formal-running hand and the wild cursive hand. They all developed from the official script.

Here we need to talk about the current "simplified Chinese characters" and the way of arranging them. Nearly half a century ago, for convenience in writing and reading, the government stipulated the use of simplified Chinese in daily writing and typesetting. If there are several ways of writing a character, only one is adopted. Typesetting is horizontal, from left to right, and the lines run from top to bottom. However, calligraphic writing retains its traditional right-to-left and top-to-bottom patterns.

Four Treasures of the Study

Traditionally, a man of letters has brushes, paper, ink sticks and ink slabs in his study. These "four treasures of the study" are essential for the development of the calligraphic art.

The Brush. The Chinese writing brush is made of goat's hair, rabbit hair or the tail hairs of weasel. Such a brush is soft and has good elasticity. Soaked in ink, it has what is known as "capillarity", which combined with the strong ink permeability of a special Chinese paper, making the strokes in a calligraphic work more vivid, varied and pretty.

The use of the Chinese writing brush can be traced back 6,000 years. In the early years, the brush was very simple. It seems that the pictures, symbols and characters on ancient pottery, painted in red and black, were done with brush strokes.

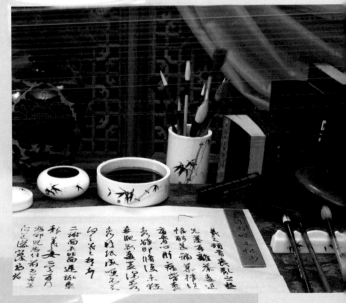

Four treasures of the study.

The earliest brush intact today was found in a fifth century B.C. tomb of the State of Chu in 1958. A large number of inscriptions on bamboo strips were unearthed at the same time.

In the fourth century, the skill of brush making saw great progress. The Chinese writing brush became more suitable for calligraphers to bring their skill into full play. It had four features, summed up as follows: First, the tip of the brush could display the delicate changes of strokes. Second, its smooth end hair could make writing vigorous while it spread across the paper. Third, its cone shape made it easy to move in all directions. Fourth, it was durable, and kept its elasticity and softness longer. With such a brush, the calligrapher could write characters in different shapes, displaying different intensities and rhythms. Using different thicknesses of ink, the characters become three-dimensional.

The brushes from Anhui, Jiangsu, Jiangxi and Henan provinces are the most famous in the country. The biggest one was made by a factory in Tianjin in 1979. It is 157 cm long including the 20-cm-long hair end, and it weighs five kg. It can soak up one kg of ink. On the morning of September 14, 1979, calligrapher Yang Xuanting from Beijing wrote four characters meaning "Long Live the Motherland" on a piece of Xuan paper 100 cm long and 150 cm wide with this brush to mark the 30th anniversary of the founding of the People's Republic of China.

In ancient times, the brush was made of the hair of a newborn baby. More than 1,400 years ago, an old woman from southern China invented a brush with a newborn's hair inside and rabbit hair outside. It is said that it was a favorite brush of Xiao Ziyun, a famous calligrapher of the time. Even today, some people ask writing brush manufacturers to make a brush with the hair of a newborn baby. But they do not use it, and keep it as a souvenir, wishing their child will be inspired after he or she sees it after growing up and become determined to be a man or woman of letters in the future.

Paper. Paper, the compass, gunpowder and printing are the four great inventions of China. It is said that paper was invented by Cai Lun (?-121) of the Eastern Han Dynasty. The *History of the Eastern Han Dynasty* explains clearly the old paper-

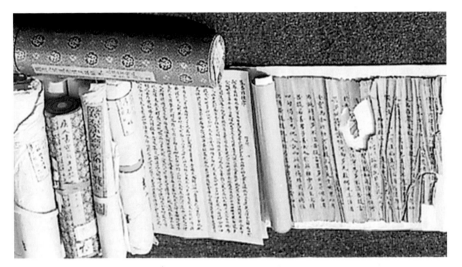

A roll of calligraphy.

making technique. In the second half of the 20th century, ancient paper discovered in Shaanxi and Gansu provinces showed that paper made of plant fiber was used during the Western Han Dynasty (206 B.C.-A.D. 25), earlier than the Eastern Han Dynasty.

Paper used for calligraphy.

After Cai Lun died, his disciple Kong Dan tried to make durable paper to draw a picture of him to cherish his memory. He failed time and time again, until he tried using the fibers of the bark of a dead tree. This turned out to be endurable quality paper.

The paper mostly used by calligraphers and painters is Xuan paper from Xuancheng and Jingxian in Anhui Province. This type of paper is made of bark of the wingceltis tree and rice straw. After being treated with lime and bleached in the sun, the fibers are made into pulp. Xuan paper is white, delicate, soft, vigorous and resistant to insects. It keeps colors for a long time. Owing to the

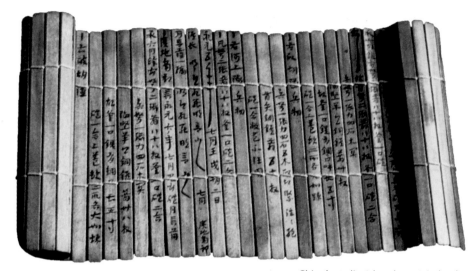

China's earliest bamboo strip book.

paper's strong absorption quality, the ink on the paper demonstrates a variety of appearances. If a brush soaked in watery ink moves quickly, the stroke will be dark in the center, and the ink around it will show lighter layers. If a brush soaked in thick ink moves quickly, there will be some white streaks in the stroke, reminiscent of a waterfall. Such stroke will add vigor and interest to the whole calligraphic work.

Ink and ink slabs. The traditional ink used for producing calligraphic works and paintings is special too. It is made by rubbing a rectangular or round ink stick on an ink slab with a little water. The ink stick is made of the soot of Tung oil, coal or pine wood, animal glue and perfume. It is viscous but does not coagulate in lumps. Excellent calligraphic works executed hundreds of years

ago are still bright today. The strokes done with thick, thin or dried ink are different. Some are black and some are light black. In the eyes of the viewer, they express different weights.

41

The use of ink can be traced back to the New Stone Age, some 5,000-7,000 years ago. Pottery found in the New Stone Age Banpo Village, in Xi'an, shows traces of charcoal ink.

Ink sticks.

Even today, many calligraphers still use traditional ink sticks, finding that the process of grinding the ink gives them inspiration.

After the Jin Dynasty, calligraphic works always carried the names and seals of their executors. In the Song Dynasty, calligraphers started to add other tokens indicating their aesthetic mood, aspiration and interest. The collectors of a work by a famous calligrapher would put their seals on the work too. Sometimes a famous calligraphic work has passed through the hands of dozens of collectors. I once saw one work with more than 60 collectors' seals and signatures. The black characters and the red seals really bejeweled the work.

Ink slabs appeared in the third or fourth century, after the use of ink balls and ink sticks. A similar device had emerged

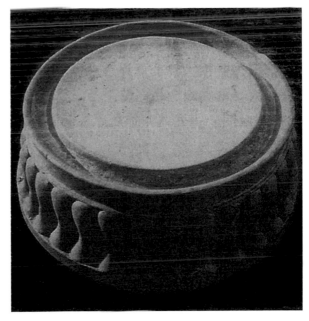

Glazed pottery ink slab used by a Tang princess. It was unearthed in Luoyang, Henan Province.

earlier for rubbing dyestuffs or foodstuffs. The earliest rubbing device intact today is some 6,000 years old. There are many ink slabs that date back to the third century, some demonstrating excellent workmanship. There are old ink slabs shaped like a turtle or stringed instrument. Today, many people collect and study ancient ink slabs.

Most ink slabs are made of stone, but there are also porcelain, pottery, bronze and iron ink slabs. Among ancient stone ink slabs, there is a jade-like one which is transparent, and ingeniously and delicately made. The ink rubbed in it cannot freeze even in the coldest weather. Famous stone ink slabs include the Lu ink slab from Shandong Province, Duan ink slab from Guangdong Province, She ink slab from Anhui Province and Tao ink slab from Gansu Province.

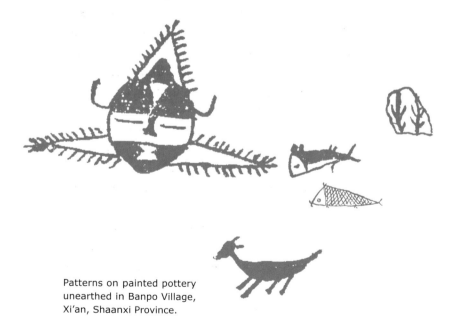

Patterns on painted pottery unearthed in Banpo Village, Xi'an, Shaanxi Province.

43

Beauty of the Strokes

Calligraphic characters are quite different from those written purely for decoration and the characters of the neat but stiff style used by the officials of the Imperial Academy. Also, they are different from those which appear in ancient or modern books. The lines and individual characters which appear in calligraphic works are vigorous, and full of feeling and thought. Also, they demonstrate a moving, progressive and rhythmical beauty.

Now we will discuss three structural forms essential to calligraphy. They are strokes, characters and lines, which join together to reflect the beauty of the work.

Among these three, strokes are basic, because all the characters and lines are composed of strokes. The characters and lines are the tracks of movements or arrangement forms of the dots and strokes. Vigor, shifting, rhythm, change and harmony are key elements of the beauty of the dots and strokes, and are also the key elements of the beauty of the characters and lines. Certainly, these key elements demonstrate different proportions in the strokes, characters and lines.

When writing with a brush, the key element is the vigor

of the strokes. Talking about the importance of the vigor of the strokes in calligraphy in an article, the 19th-20th century scholar Liang Qichao emphasized, "The vigor of the strokes is the main criterion for judging whether the work good or not." Sun Guoting, a calligraphy critic of the Tang Dynasty, said, "The charm of calligraphy lies in the strength of the characters." The strength of the characters means the inner power exerted in using the brush and the strength displayed by the dots and strokes on the paper. Simply dropping ink

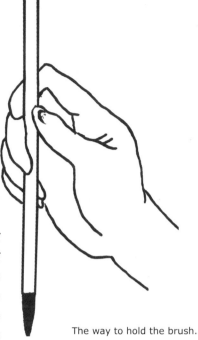

The way to hold the brush.

blots on the paper could not demonstrate strength at all. Likewise, dragging the brush across the paper would be like covering the paper with paint. While writing characters with a brush, the brush should be held vertically at 90 degrees to the paper's surface. Comparing characters written with a brush and those written with a pen, the strokes of characters written with the latter are all more or less the same thickness. But the dots and strokes of characters written with a writing brush illustrate different thicknesses, express dark or light black ink, and the speed of the movement of the brush. Also, all the dots and strokes of each character are finished in order, and they cannot be revised. This is the main difficulty in writing with a brush and the charm of calligraphy. So we can say the vigor of the strokes depends on the mastery of the brush by the calligrapher.

There are several ways to demonstrate the vigor of the strokes, but we will only introduce only two of them here.

First, more use of the tip of the brush. While writing the character the brush is held vertically and moves from the middle of the stroke. A character written this way is vigorous, smooth and natural. Opposite to this is the use of the side of the brush, when the tip of the brush moves along one side of the stroke.

Second, a good command of the technique of pressing and lifting the brush is needed. Both are the main ways to express vigor and rhythm in calligraphy. Lifting the brush a little makes the strokes delicate, powerful and smooth, and pressing down on the brush makes the strokes thick, vigorous and powerful.

The thickness or thinness, and darkness or lightness of the strokes depends on the lifting and pressing of the brush. Take 大 (big) as written in the formal script as an example.

Whiling lifting or pressing the brush, the calligrapher should deal with another pair of ways to use power: moving the brush forward and holding it in position for a while, or moving the brush slowly – like a basketball player who moves forward while bouncing the ball on the ground. Such a skill is the result of hard practice.

Various scripts have different frequencies of transfer of lifting and pressing. The wild cursive hand features swift movements of brush and fewer changes of lifting and pressing. The changes are more frequent in the lesser cursive and running styles. The official script demonstrates more transfers between lifting and pressing, especially in writing horizontal strokes, which starts with a silkworm's head and ends in a wild goose's tail, and right-downward strokes. The formal script illustrates the highest frequency of changes of lifting and pressing. But the seal script demonstrates no lifting or pressing at all. In addition, in the seal script the calligrapher uses the tip of the brush only, not the side of the brush, because this style seeks to make all the strokes of a similar thickness. One of the ways to display the vigor of strokes in the seal script is the

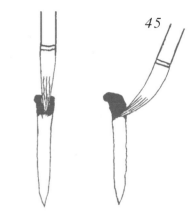

45

Moving the tip of the brush in the middle of a stroke (left).
Moving the side of the tip of the brush along one side of a stroke (right).
Different ways of using the tip of a brush in writing a vertical stroke.

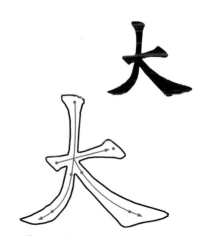

Lifting and pressing.
The red spots show the places for pressing the brush, and the arrow shows the direction of the movement of the brush.

quick or slow movement of the brush, together with the application of heavy or dry ink. The firm and smooth characters in the copybook compiled by Qian Dian, a Qing Dynasty master of the seal script, demonstrate the quick or slow movement of strokes and thick or dry ink excellently. In his last years, Qian Dian suffered from paralysis in his right side, but created charming calligraphic works using his left hand.

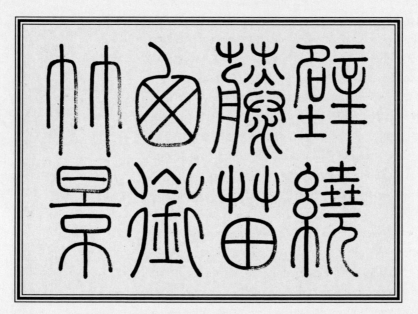

A page from the *Book of Models* by Qian Dian.

47

Beauty of Composition

From the point of view of composition, Chinese characters fall into two categories: single and compound characters.

A single character has only one method of composition, while a compound character can be two components (on the left and right, or above and below each other), three components (on the left, middle and right, or top, middle and bottom) or encircled characters (full or semi-circled).

Both the single and compound characters have a center. With a good grasp of the center of a Chinese character, it is easy to arrange all the strokes so that they are not too loose or too tight or in a strong contrast with other strokes. To help learners grasp the center of each character, many copybooks have been published for practicing penmanship. One of them is a 米 (rice) -shaped copybook (see P.49), because each square has four red crossed lines in that pattern to help the student handle the relations between the centripetal and centrifugal forces of all parts of the character.

To satisfy the requirements of the beauty of form, there are mainly five requirements, as follows:

Straight and even. While writing, it is necessary

Square characters
with four edges.

Single characters.

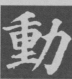

Composed of left and right parts

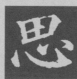

Composed of top and bottom parts

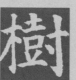

Composed of left, middle and right parts

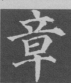

Composed of top, middle and bottom parts

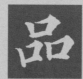

Composed of one part on the top and two parts on the bottom

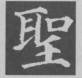

Composed of two parts on the top and one part on the bottom

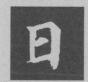

Encircled character

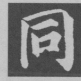

Semi-encircled character

Compound characters.

to pay attention to the balance of the lines of the character; otherwise, it will look ugly. Traditionally, calligraphers have stressed the evenness of the character's makeup, the proper length of its vertical and horizontal strokes and the suitability of darkness and lightness. This matches the esthetic requirement that beautiful people should have regular features, and that rooms and courtyards are only beautiful when everything is in good order; they are unpleasant to look at if every thing is in disorder. To hang a picture on the wall, the picture should be pleasant to look at and with suitable spaces on its left and right and above and beneath. Even a stamp should be pasted straight and even in order to give a good impression to the receiver of the letter.

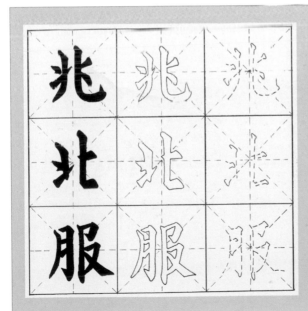

A 米-shaped exercise book

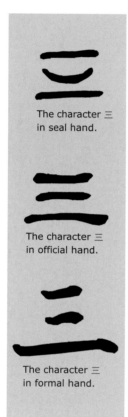

The character 三
in seal hand.

The character 三
in official hand.

The character 三
in formal hand.

Well-balanced. Characters or strokes should be well balanced. For the characters with few strokes, the strokes should be thicker, and strokes should coordinate with each other. For characters with more strokes, the strokes should be thinner, closer and well balanced.

Among various kinds of scripts, the seal script comes the first in fine balance. At the same time, this script tries to minimize the blank spaces between strokes of a character. Other scripts come in this order according to their demands for balance: official script, formal script and running script. The cursive script and the wild cursive script pay no attention to balance, as they seek only vividness and rhythm.

Uneven and not uniform. Like many things in nature, calligraphic characters are written in an uneven and not uniform way in order to display their beauty. If all the strokes of a character are straight and even, they are print characters and not artistic ones. Even the seal script shows different lengths of strokes. Take the character 三 (three) as an example. The three strokes are of the same length, but in seal hand, the stroke in the middle turns upward at the end. In official script, the two top strokes are of the same length, but the last stroke starts in a shape of the silkworm's head and ends in a shape of wild goose's tail. In formal hand, the top stroke has an upturned end, and the stroke in the middle is short while the bottom stroke is thicker.

Coherence. All the strokes or the various parts of a character should match each other, so that the coherence of the strokes can make the whole character vigorous, vivid

and rhythmic.

The coherence of a character falls into two kinds: indirect or direct. Take the character 花 (flower) as an example. It is composed of four parts, with their coherence in the middle. When writing it, the four parts should be close, and the top and bottom parts can be connected.

In general, direct coherence is used to connect two strokes in cursive and running hand. In calligrapher's hand, the dot will be written as a hook or a turning stroke in order to link it up with the next or the previous stroke. A horizontal, left-falling or vertical stroke is written so as to connect it with the next or the previous stroke.

Dynamic. This is the most important way to make a character vivid. From such strokes, an artistic work gains vitality and rhythm.

The dynamism of a calligraphic work comes from other two aspects, as follows: First is the movement speed of strokes. In the seal and official scripts, the writing of a character can be finished in one or two minutes. But in cursive or running hand, the brush moves more quickly, and it only takes several seconds to finish a character. Second, unstable and inconsistent space can be caused by the slanting of the character. In the rigorous official hand, some people make the characters straight and graceful, while others make them slanting, and the strokes are of different lengths in order to display their vigor, vividness and rhythm. In running, cursive or wild cursive hand, this is out of the question. *Prose on the Goddess of the Luo River*, written by Zhu Yunming (1460-1526) of the Ming Dynasty, demonstrates the coherent and dynamic strokes

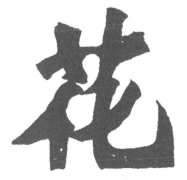

The character 花 (flower).

52

in cursive hand, and displays the charm of the characters and Zhu's excellent skills of controlling the speed of brush movement and rhythm. Zhu, Wen Zhengming, Tang Bohu and Xu Zhenqing were four talented calligraphers in the Suzhou area and made great contributions to the development of calligraphy in the Ming Dynasty.

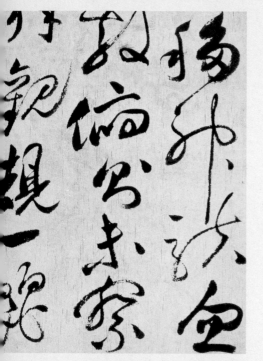

Part of *Prose On the Goddess of the Luo River*, written in cursive script by Zhu Yunming.

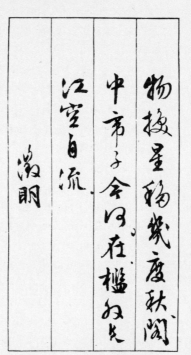

A poem in an ancient famous prose *Preface to the Pavillion of Prince Teng*, written in running script by Wen Zhengming.

53

Beauty of the Whole Work

When a person is appreciating a painting, he does not see the coloring of one part or a part of object; he views the whole work and judges whether it is beautiful or not. Then he carefully appreciates the details. While enjoying a piece of music, he does not appreciate parts of it, but the charm and rhythm of the whole piece.

It is the same with the appreciation of a calligraphic work. Calligraphy critics always comment on the whole work before studying its parts in detail. The critic moves from the whole work to the details, and then from the details to the whole work again.

While there are rigorous rules used in the formal, official or seal script, it seems that there are no rules in cursive or running hand. But, in fact, there are rules. Especially in wild cursive hand, the calligrapher does his best to write with vigor, dynamism, fantasy and grace. Cursive script also needs more consideration about the overall arrangement of the characters. Although the calligrapher may change his approach a little according to the situation, he sticks closely to the rules.

A good calligrapher is like a macro-control systems

engineer. With his knowledge of maths, especially in operational research, the engineer, with the help of a computer, draws up an ideal plan, and completes a design for a complicated project. When a system needs to be revised, he perfects the original plan immediately. The "calligraphic engineer," by relying on various kinds of data governing strokes, characters and lines, and the mastery of the art in his hand and heart, completes or revises his calligraphic plan, and finishes it on the paper at a speed as quick as a computer operation.

The most important thing concerning the composition of a calligraphic work is liaison between the characters and lines, which demonstrates rhythm in changes and dynamics in stillness.

The liaison can be realized in three ways, as follows:

The liaison between blood and vein. The characters in each line should be linked to and match each other in both shape and manner. Writing characters is like entertaining guests. You should look after all the guests, make them feel at ease so that they can talk cheerfully and humorously. No one should feel uncomfortable and lonely.

Wang Xianzhi, son of the famous Wang Xizhi, wrote *Mid-Autumn Scroll* (see next page) in running-cursive hand. This scroll since ancient times has been praised as an excellent calligraphic model in the liaison between blood and vein. Only 22 characters are visible on this scroll, but they still demonstrate the feature of coherence. On each line, the characters or their strokes are connected in a "one-stroke way of writing." This scroll was collected by the Ming Emperor Qianlong in his Sanxi Studio.

Coexistence of substance and blank. In a calligraphic work, the places with strokes are real things and the places between characters or lines are blank. Both constitute an organic entity. As in a traditional opera, vocal music with words is true while the independent instrumental music that precedes, follows or comes in the middle of an area is empty, which arouses enthusiasm and heightens the atmosphere. In a piece of Western music, the process in which the music decreases gradually and even disappears is one of from substance to blank. The blank plays a

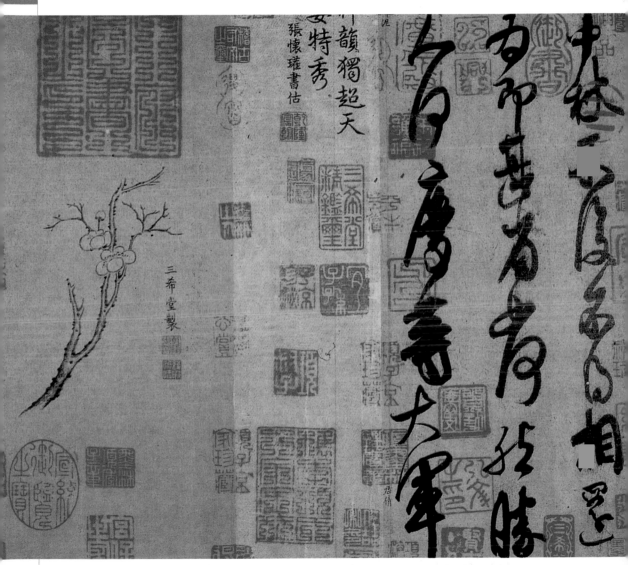

Mid-Autumn Scroll, written in running-cursive hand by Wang Xianzhi.

role the substance cannot play. A line from a classical poem describes it thus: "Here quietness seems better than the music itself."

Chinese horticulture also pays attention to the coexistence of substance and blank. The man-made structure always has a landscape in the distance as its background in order to increase its charm. The Summer Palace on the western outskirts of Beijing is a good example of this. It is mainly composed of the man-made Longevity Hill in the north and Kunming Lake in the south. On the slopes and at the foot of the hill there are pavilions, halls, the Long Corridor and courtyards. The Cloud-Dispelling Gate and the Pavilion of the Fragrance of Buddha are the most magnificent of the buildings. Kunming Lake is beautiful. There is the West Dyke by the lake, and in the lake there is a small islet with a pavilion on it. The islet is linked to the land by a 17-arch bridge. If the hill and other buildings in the Summer Palace are main scenes, the vast lake surface is serving as a foil scene. In addition, in distance, there are Yuquan Hill and the Western Hills. Yuquan Hill changes in different seasons, on sunny or rainy days, and in the morning or at noon, which makes the garden more charming and attractive.

In calligraphy, the characters and blanks appear simultaneously when the dots and strokes are placed on the paper. They can not be revised. Unlike other arts such as painting, especially oil painting, when there is time for the painter to think about and revise the painting time and again, calligraphy is strict, and needs a delicate,

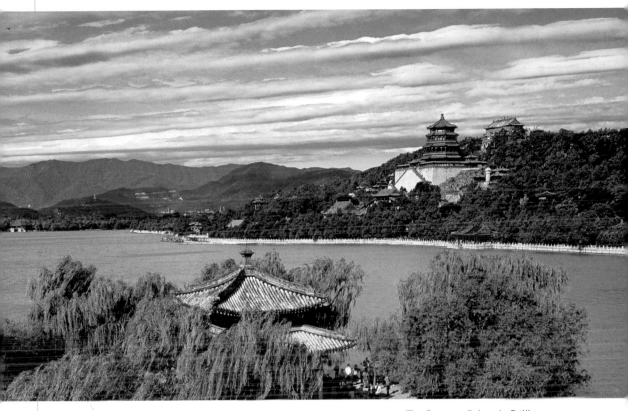

The Summer Palace in Beijing.

dexterous and proficient mind and hand.

Well-proportioned. This is another way to seek changes in strictness. The seal, official and formal scripts follow a strict rule which demands that all characters are placed on the central axis of the line – like beads on a hidden string.

But cursive and running scripts do not follow this rule closely. Most characters do not follow the central axis, and some are far away from it. On the same line, characters can be crooked and not well proportioned. In *Du Fu's Ode to He Lanxian* (see next page) written by Huang Tingjian of the Song Dynasty in cursive hand, all the characters are crooked and free.

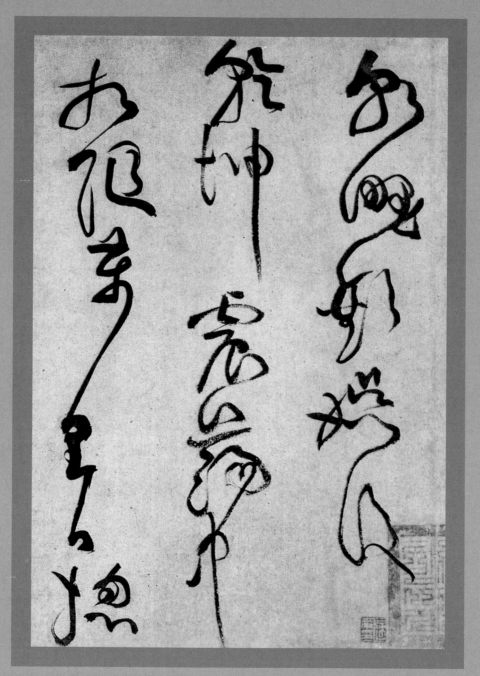

Part of *Du Fu's ode to He Lanxian*, written in cursive hand by Huang Tingjian.

Reflection of Excellent Skills Beyond the Work

As the standards for assessing calligraphic works are strict, people find calligraphy easy to learn but difficult to master.

Beginners should practice following model books, which can be obtained in any bookstore. But you should select one according to your own interests. You should follow the models closely. This is an important first stage for learning calligraphy, and takes several months. Later, you can diverge from the models. If you want to become a famous calligrapher you have to copy several model books and finally write characters freely and establish your own style. Satisfaction comes from a comparison of your skill today with that of yesterday rather than a comparison of your skill with that of others.

While using the strength of your fingers, wrist and arm, you will use the strength of your waist and legs too in writing characters. If you stand when writing, you can exercise all the parts of your body. A deep breath will speed up the circulation of the blood, and thus massage your

internal organs. As a result, you will feel physiologically well.

In addition, calligraphy imparts an aesthetic satisfaction which is better than physiological well-being, which comes from your free creative activities. People love creation. I remember the feelings I had when I began to learn to use the writing brush for the first time in my childhood.

As well as inspecting carved inscriptions and visiting calligraphy exhibitions, the calligrapher should also acquire other knowledge in order to improve his artistic level and creativity. Ancient calligraphers and painting masters urged artists to visit famous mountains and rivers, observe natural scenery and improve their social knowledge in order to increase their sensitivity as regards the beauty of the world and nature. Ancient calligraphy critics said that the characters are a reflection of the mentality of the calligrapher. They also said that calligraphic works by people with noble natures are more widely appreciated.

Through learning and practicing calligraphy, the calligrapher increases his knowledge and accomplishments. In this way, he may become an erudite, civilized, noble and progressive person who loves life. Sun Guoting, a calligraphy theorist of the Tang Dynasty, said that he hoped that calligraphers would achieve maturity in both moral character and calligraphic skill.

Following are positive and negative examples of people's appreciation of calligraphic works according to the moral characters of the calligraphers.

Yue Fei, a famous general of the Song Dynasty, was

Image of Yue Fei

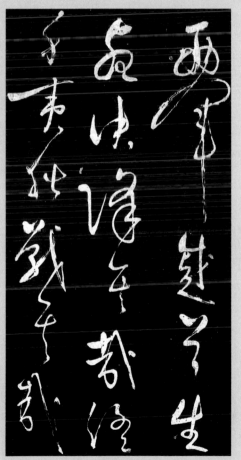

put to death after being unjustly charged with treason. He was a noted calligrapher. His calligraphy work *Prayer for the Dead on an Ancient Battlefield* in cursive hand reminds people of his lofty sentiments and heroic merits. Later, it was discovered that this work was not his. But it is still being reprinted and copied. Maybe somebody admired Yue Fei's lofty moral character, and put his name to this piece of calligraphy in order to hand down his memory.

Part of *Prayer for the Dead on an Ancient Battlefield*.

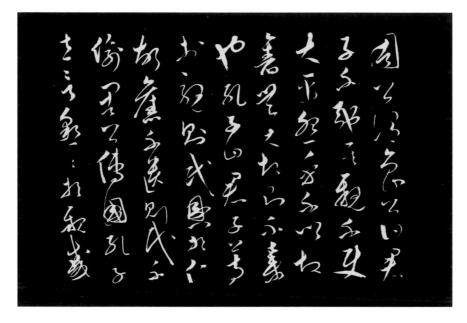

Part of *Mottoes by Xie Changyuan,* written in cursive hand by Wen Tianxiang (1236-1283), another patriot of the Song Dynasty.

The negative example concerns Zhang Ruitu. His calligraphy is powerful and dynamic (see next page), especially his big calligraphic works in cursive script are impressive, with free strokes and inking, and tremendous momentum. But his character was held in contempt by the people of his time and later, and his calligraphic artistry was overshadowed by his bad character. Zhang was an adopted son of the powerful eunuch Wei Zhongxian and was once a prime minister. The calligraphy critics of later generations detested him and ignored his works. People detest the calligraphic works of people of bad character, because it is very difficult for viewers to separate the work from the calligrapher.

The dynamics of calligraphy is another point of

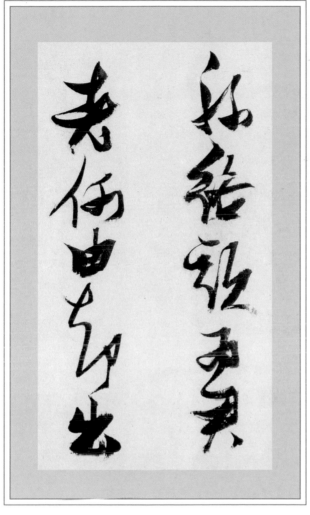

Part of *Ode to Longma (a kind of horse)* of *His Escellency Deng*, written in running hand by Zhang Ruitu.

attraction. The beauty of the dynamics of a calligraphic work pulls the viewers closer to the calligrapher and lets them become cooperators or bosom friends of his by interpreting and recreating the work, no matter whether the calligrapher lived 1,000 years ago or 1,000 miles away.

Careful viewers with experience and strong imagination

may have more than one interpretation of a calligraphic work. The aesthetic implications and value of a calligraphic work are variables. The viewer indulges in the appreciation of the beauty of the dynamics of the calligraphic work and, with rich aesthetic appreciation, cultural knowledge and life experiences, explores the implications and value of the calligraphic work, and tries to fathom the sentiment, thinking and artistic principles of the author and the spirit of the time behind the work. All these things the calligrapher finds difficult to explain, so it is up to the viewer to explore them. This exploration, over the centuries, has added more new contents which are beneficial to the creation and development of calligraphy.

Conveying the Emotions
of the Author

The calligrapher wants to express his personality, knowledge and sentiments through the characters on the paper, and tries to personify the characters.

To arouse the consciousness of life is a common function of all kinds of arts. Owing to its power to express the quality of the person and the correspondence of its rhythm with the rhythm of human emotion, calligraphy can arouse the strongest consciousness of life. In this aspect, only music can compare with calligraphy.

Romain Rolland, a French writer, said that when he talks about the quality of music, the most important things about music are to display the soul of the people and to expose the secret of inner life. First of all, music is about feelings and inner experience. Their emergence demands nothing but the soul and songs.

Chinese calligraphy, soundless music, can reflect the secrets hidden deep in the heart. People have different characters and are influenced by different historical periods. They learn calligraphic skills from different

teachers, and have different educations. Thus, calligraphers write characters in different styles expressing their personal characters. This is reason for the frequent changes in the development of Chinese calligraphy.

The affection the calligrapher puts into strokes comes from three sources: his character, knowledge and sentiments. This chapter deals with one of these three sources.

Calligraphic works fall into two kinds: steadfast and soft. They are easy for the viewer to detect. Calligraphy critics mention them frequently, and they reflect the personality of calligrapher.

Calligraphic works reflecting steadfastness are vigorous, powerful, fantastic, loose and magnificent. Some calligraphy critics comment that such works are as forceful as dragons and tigers, as quick as a warhorse charging, like a drawn sword or a bent bow, a giant with his fist crushing his opponent or a steep mountain cliff.

Calligraphic works reflecting the beauty of softness are delicate, elegant, warm and graceful. Some calligraphy critics compare them to beautiful women with flowers on their heads, dancers with delicate waists, warm and gentle spring breezes, and nice flowers and plants.

Various calligraphic scripts have steadfast and soft styles. The official and formal scripts demonstrate the steadfast and soft styles remarkably. Following are two examples copied from stone inscriptions in official script.

Tablet to Zhang Qian, carved in 186, the last stage of the Eastern Han Dynasty, is powerful and vigorous. It contains 672 characters. The calligrapher purposely made the strokes look lofty. Each character seems to extend outward in order to look larger. The uneven strokes, thick right-falling strokes and the horizontal strokes with an upward end demonstrate bold and unrestrained features of writing. The square turning strokes illustrate firm and powerful features. The tablet is solemn, but solid; ponderous but proud. The calligrapher did not leave his name on it, but we can imagine that he was a courageous person. Today the tablet is housed in a temple in Tai'an, Shandong Province.

Tablet to Cao Quan, carved one year earlier than *Tablet to Zhang Qian*, contains

900 characters. All the characters are graceful and smooth. Appreciating these characters is like bathing in a spring breeze or having a chat with an old friend. The calligrapher was probably a refined and cultivated scholar. Today the tablet is preserved in the Stele Forest in Xi'an.

Now we take two named examples to illustrate the close relations between personality and writing styles.

Yang Ningshi of the Five Dynasties was a son of the

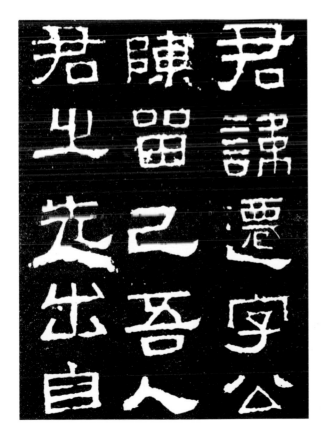

Part of *Tablet to Zhang Qian* in official script.

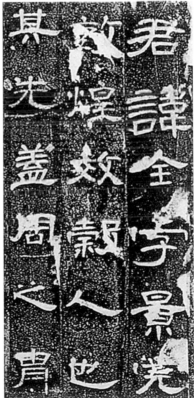

Part of *Tablet to Cao Quan* in official script.

晝寢乍興朝飢正甚忽蒙
閤翰猥賜盤飧䝮當一葉
秋之初乃韭花逞味之始
助其肥羜實謂珍羞充腹
之餘銘肌載切謹修狀

prime minister and was himself a high-ranking official. But he pretended to be foolish in order to preserve his moral integrity. He visited many scenic spots. His calligraphic works are innocent, brilliant, free, unrestrained and wild, matching his personality. *A Short Note of Chive Flower*, written by him in running hand, impresses people with its loose, natural and free-spirited style. But *A Short Note of Hat Summer*, also by him in running hand, is hurried, crowded, disorderly and slack. Only a person who was free from convention, forgot himself and the things around him and had the power of understanding his life and art could complete a calligraphic work like this one.

Wang Anshi, a politician, writer and thinker of the Song Dynasty, had lofty ambitions when he was young. He was of the opinion that political thinking should change as time changed, and opposed following routine. After he accepted the post of prime minister, he actively drew up new laws. He wrote extensively on political matters, criticizing social evils and proposing solutions. In addition, he was a good calligrapher. His unrestrained characters show his intelligence and uprightness, although sometimes his self-opinionated and hot-tempered personality peeps through.

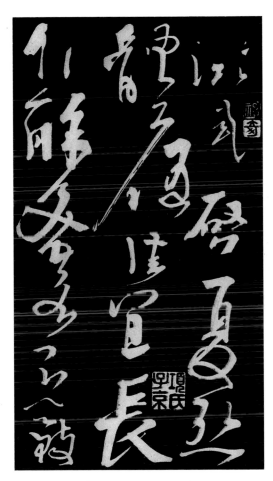

A Short Note of Hot Summer written in running hand by Yang Ningshi.

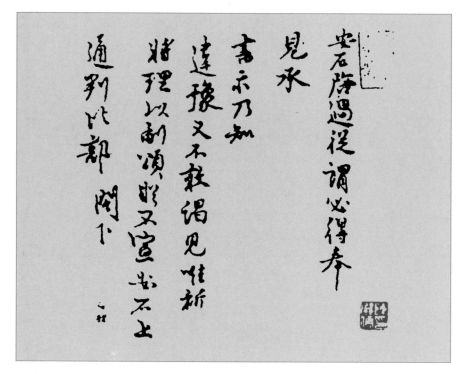

A Brief Note written in running hand by Wang Anshi.

Here we should point out that calligraphic works basically illustrate the personalities and sentiments of calligraphers in a brief and abstract way, because it is difficult to match the shapes and quality of calligraphy to the calligrapher's personality.

71

Expressing Knowledge
of the Author

If a calligrapher expresses his personality through ink
strokes unconsciously, he nevertheless expresses his tal-
ent and aesthetic sense through strokes consciously. If a
calligrapher displays his personality through works briefly
and generally, he nevertheless demonstrates his talent in a
unique, thorough and attractive way, in order to arouse a
strong response from the viewer.

Talent and aesthetic sense are rational, but also emo-
tional, and play a strong guiding and promotional role for
the creative enthusiasm of the calligrapher. Without them,
the calligrapher finds it difficult to create excellent works
and keep up his spirits in his study of calligraphy and striv-
ing for perfection. Also, if a viewer cannot see the high
aesthetic sense and features of the calligrapher while ap-
preciating his calligraphic works, he will find it difficult
to have and keep a constant interest and increase the level
of his aesthetic appreciation.

The skills the calligrapher demonstrates in his works
are the most important, valuable, sustained and eternal self-

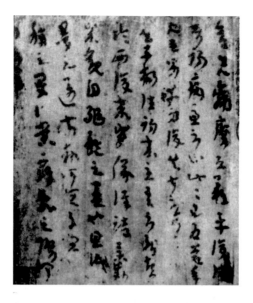

A Letter Informing Recovery of Relatives and Friends, written by Lu Ji.

existing forms. The characters written in ink or carvings on stone (or tortoise shells or animal bones) silently illustrate the artistic soul of the calligrapher.

The earliest intact handwriting on paper by a famous calligrapher is a letter written by Lu Ji (261-303), a man of letters and calligrapher of the Jin Dynasty. It is preserved in the Palace Museum in Beijing. It was held up as a model of its genre by later generations. This letter – consisting of 84 characters arranged in nine lines – tells about his relatives and friends during a time of civil strife. Written with a worn-out writing brush, the characters demonstrate a style similar to both the "zhang cao" cursive script and "modern" cursive script. Lu Ji was born into a noble family, and built a good reputation for writing excellent essays. But he fell victim to political intrigue, and died at the age of 42.

Wu Zetian (624-705), the only empress in Chinese history, was also a calligrapher. She copied calligraphic works by Wang Xizhi and Wang Xianzhi of the Jin Dynasty. Her *Tablet to Prince Shengxian* (see next page), written in the running script, shows powerful and full strokes and dots. In it there are several strange characters which hint at her unique personality. She usurped the power of the Tang Dynasty after she became empress, and changed the title of the dynasty during her rule. As an empress, she was arbitrary and extravagant, and aroused much popular opposition. Nevertheless, she is admired as a calligrapher, being held second only

to the famous female calligrapher Lady Wei, or Wei Shuo (272-349), a teacher of the young Wang Xizhi.

The talents of the calligrapher include the understanding of the significance of making calligraphic works beautiful and the ability to master calligraphic techniques. Such skills are gained by constant observation, practice, summarization and understanding by the calligrapher in his study and creation of calligraphic works. Of these, some are done consciously, while some are done unconsciously and understood later. Many excellent stories about famous calligraphers reflect the role of their skills in their creations.

Li Yangbing, a great master calligrapher of the Tang Dynasty, made his works beautiful by observing the qualities, features and forms of various things in nature. He said that he got to know round, square, flowing and standing forms from Heaven, the Earth, mountains and rivers; the rules concerning the horizontal and vertical movements from the sun, the moon and the stars; growth and spreading from the clouds, sunrise, sunset and plants; and the functions of bending, spreading and flying from insects, fish, birds and animals. The *Record of Three Tombs* (see next page) written by Li Yangbing in the seal script is praised as one of the calligraphic wonders of the Tang Dynasty for its graceful, even, delicate and flying strokes.

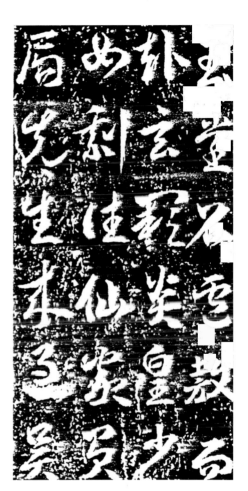

Tablet to Prince Shengxian, written in running hand by Wu Zetian.

Lei Jianfu of the Song Dynasty drew inspiration for how to move his brush from the noise of flowing water. He always considered that his running hand works were not as natural as those of his predecessors. Later, he was a local governor of Sichuan. One day, he was taking a nap in his office, when he heard the noise of surging river water. Immediately, he spread a piece of paper on a table and tried to display his feelings about the rhythm and movement of the surging waves through characters. After that, his calligraphic technique improved greatly.

Zhu Changwen of the Song Dynasty commented on the cal-

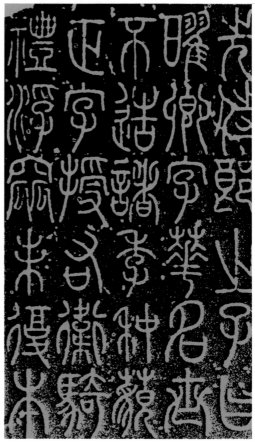

Record of Three Tombs, written in seal script by Li Yangbing.

ligraphic works by Yan Zhenqing of the Tang Dynasty: The dot is like a dropped rock, the horizontal stroke like a shred of summer cloud, the hook like bending a metal stick and the backward hook like a crossbow ready shoot. Calligraphers find such forms in nature and their own lives, and use them in their process of creation. On paper it is unnecessary to illustrate a real rock, cloud, metal or bow, but the characters should display the dropping of a rock, the bending of a metal stick, the launching of the arrow and the light and changeable shape of clouds. Yan Zhenqing had outstanding talent, a sound aesthetic appreciation, and the courage and ability to use his talents and understanding for the creation of calligraphic works.

Feelings, Dionysus and Cursive Style

Human beings have all kinds of emotions, including happiness, hatred, grief, desire, love, disgust and fear. The brief emotions such as joy, fury and extreme grief are called passions, while the sustained emotions such as happiness, sorrow, hatred, boredom, admiration and restraint are moods. Both passions and moods affect calligraphic style.

Emotion falls into two categories: positive and negative. In his *Prose of a Brief Account of Oneself* (see next page), Huai Su, a cursive script master, gives good examples of works written when the calligrapher had positive emotions. Huai Su was a monk who lived during the Tang Dynasty. But he did not follow monastic rules strictly, and was addicted to drink. His work has 126 lines, and is a masterpiece displaying his excellent calligraphic techniques while giving accounts of his life. It quotes verses and sentences by the well-known poets and other famous figures eulogizing his calligraphic techniques, and at the same time illustrates his unconstrained and self-satisfied emotions with romantic and free strokes. The characters

are full of life, rhythm and integration. Like a perfect symphony, it stirs the soul of the viewer.

Lu You (1125-1210), a Song Dynasty poet, left 9,300 poems. One of them is titled *Ode to Cursive Hand* relating his experience in producing a calligraphic work when he was depressed. He was eager to do something for his country, and encouraged people to resist foreign invaders. When he was young, he fought on the war front several times.

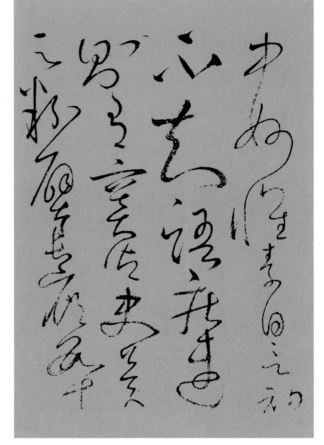

Prose of a Brief Account of Oneself, written in cursive script by Huai Su.

When he was 57, disillusioned with politics, he retired to his hometown. One of his poems goes, "All my money has gone on three thousand gallons of wine / Yet I cannot overcome my infinite sadness / As I drink today my eyes flash fire / I seize my brush and look round, the whole world shrinks / And in a flash, unwitting, I start to write. / A storm rages in my breast, heaven lends me strength / As when dragons war in the waste, murky, reeking of blood / Or demons topple down crags and the moon turns dark. /

At this moment, all sadness is driven from my heart / I pound the couch with a cry, and my cap falls off. / The fine paper of Suzhou and Chengdu will not serve / Instead I write on the thirty-foot wall of my room." It is pity that this calligraphic work has been lost, as it must have been a dynamic one.

The two calligraphers mentioned above created wonderful works in a cursive or wild cursive script, and expressed their feelings in their works when they were drunk with wine. It is said that wine removes the inhibitions. So when an artist or calligrapher is drunk he ignores common customs and artistic rules, and enters a free and frank realm for creating a work to fully demonstrate his personal charac teristics, and tries an artistic style he has never tried before.

Now we shall analyze the features of the cursive script. Unlike other scripts, in the cursive script the strokes always are linked together; some are written with a semi-dry brush. The characters are tilted or not, as the calligrapher wishes. The space between the lines is sometimes narrow and sometimes wide. All these ir regular rules are a result of the rhythm of the agitation and uneasy feelings of the calligrapher.

The cursive script (especially the wild cursive script) is the most unconstrained among the calligraphic styles, being free from the restrictions of other styles. This can be illustrated by reference to painting. Figure painting is much more restricted than landscape painting. Landscape painting gives more room for the painter to create. The former is like other calligraphic scripts, and the latter is like the cursive script. The cursive script demands a differentiation of written characters, but it is unnecessary to follow the calligraphic rules strictly. Also, the structure of the dots and strokes can be changed. With all these advantages, in the cursive hand the calligrapher can do his best to seek beauty, get all his feelings off his chest and fully demonstrate his calligraphic techniques.

Also, among all kinds of calligraphic scripts, the cursive script features the as pect of time. In other scripts, the aspect of time is featured in the movement orien tation of strokes and the order of strokes. So the viewers do not see the feature of time, are not interested of the time order. But the feature of time in the cursive

script is the result of continuity between two characters or between two strokes. So these features can be seen directly by the viewers, and arouse great interest among them. So, using the visible feature of time, inspired calligraphers move their brushes quickly to express their emotions and feelings.

But we should point out that although calligraphic works can express the feelings of the calligrapher when he moves his brush, he can not express his feelings directly through a certain character, stroke or line because these are not a materialized form of a kind of feeling. That means we cannot say this stroke or line expresses one kind of happiness and that stroke or line expresses sadness. The characters cannot express the calligrapher's inner feelings, as the characters used in certain poems can.

For the calligrapher, his emotions and feelings can add motion to his creation, and help him to move his brush smoothly. The calligrapher does not try to, and cannot, express or record his concrete feelings. His work displays only the quick rhythm and other changes in the structure of the characters. For the calligrapher, this is enough. He knows quite well that his work refracts his soul in such an obscure language more powerful than spoken language.

Calligraphy and the Traditional Chinese Cultural Mindset

Human mask design on a bronze three-legged tripod.

In the above chapters we have talked about the features, evolution and major functions of Chinese calligraphy. Now we will talk about the relations between calligraphy and the traditional cultural mindset of the Chinese people.

The cultural mindset of the Chinese people can be seen in the painting on prehistoric pottery and the human mask design on a bronze three-legged tripod of the Shang Dynasty displayed in the Museum of Chinese History, in the three halls of the Palace Museum in Beijing and in the Longmen Grottoes in Henan Province. Also, it can be found on tomb bricks of the Qin Dynasty, roof tiles of the Han Dynasty, poems of the Tang Dynasty and rhymed verses of the Song Dynasty.

Calligraphy is an elegant art, with a history of several thousand years, and fully displays the cultural mindset of the Chinese people. Such a cultural mindset is rooted in

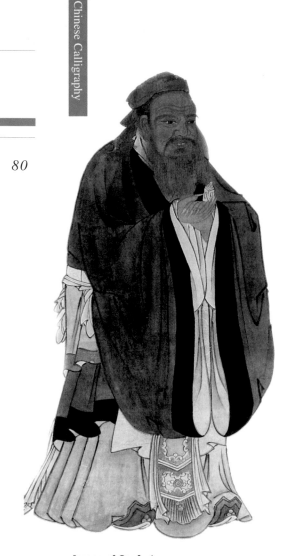

Image of Confucius.

classical philosophical thinking. It can be dated back to the pre-Qin period and also embraces Confucian and Taoist thought. Confucian thought and Taoist thought supplemented each other, and became important factors promoting and affecting the evolution and development of the aesthetics of calligraphy.

Confucius (551-479 B.C.) was the founder of the Confucian school of thought which was predominant in China for more than 2,000 years, and represented the main social and cultural trends of ancient China. The Confucian school advocated kindness, loyalty, forgiveness and the moderation. Concerning the ideal outlook on life, it advocates progress and optimism. In the field of art, it affirms natural beauty, and emphasizes the integration of beauty and kindness. It believes the art can mold a person's temperament and educate a person in aesthetics, thus helping that person enter a lofty spiritual realm and promoting the harmonious development of society.

The founder of Taoism, Lao Zi, lived in the same historical period as Confucius, although slightly before him. The essence of the Taoist thought emphasizes that thinking and behavior should obey natural laws. In its outlook on life, Taoism focuses on retreat, avoidance and passiv-

ity. In the sphere of art, it emphasizes the ideal of going back to nature and looking for the quality of nature and human beings. Taoism yearns for artistic romanticism, and maintains that aesthetics should be separate from concrete practice, and that people should not seek after beauty which is combined with benefits and satisfies physiological needs. Real beauty should be natural, and exist in a spiritual realm free from outside shackles. Such artistic aesthetics are more profound than those of Confucianism, and exerted a significant influence on later generations.

In general, the common aesthetic outlook held by these two schools and displayed in calligraphy and other arts can be seen in the following three aspects: the beauty of simplicity, the beauty of momentum and rhythm and the beauty of moderation.

The beauty of simplicity. Confucianism and Taoism have a common viewpoint in that they believe that nature and all the things in the world are complicated but are made of the simplest materials and act according to the most fundamental law.

The Book of Changes, one of the Confucian classics, maintains that in the universe there are two kinds of *qi*: *yang* and *yin*. Both are contradictory and unified. Integrated, they can produce everything in the world. Sim-

81

Image of Laozi.

plicity makes people easy to understand and obedient, and makes all things in the world rational.

The Book of Rites, another Confucian classic, says the most popular music is plain and the greatest rite is simple. Both can bring into full play the role of aesthetics and education.

Laozi, the classic of Taoism, says that the Tao (Way) exerts a unified power which splits into two opposite aspects. Then, a third thing is produced, which in turn produces the myriad things. This classic says the strongest voice seems to be no voice, and the most vivid image seems to be no image.

Such thoughts are expressed in various kinds of traditional Chinese arts.

Traditional Chinese opera (such as Peking Opera) has a simple technique of expression. On the stage, there is no setting at all, and few props, except for a desk and a chair or two. There is no real door or carriage for an actor or actress to open and close or sit in. Three or four steps represent a long journey, and six or seven persons represent a large army. The actors and actresses stir the imagination of the viewers with their movements, leading them to imagine that the performers are rowing a boat, sitting in a sedan chair or shooting a wild goose.

To display the world in simple colors and lines is a principle of Chinese painting. Especially in freehand brushwork, the painter seeks after the spirit of the image, the things in his mind and the things he understands, instead of sophisticated images. With just a hint, he passes on the posture and image of the thing in his mind. What

A scene from the Peking Opera *Xiang Yu the Conqueror Bids Farewell to His Favorite Concubine.*

he wants to convey to the viewer is not his sharp and careful observation and mimicry, but his great imagination, creativity and rich feelings. Expressing things in a vague way usually has a stronger appeal.

Ni Zan of the Yuan Dynasty was a powerful promoter of the simple painting style. His landscape paintings have little brushwork and few figures. His paintings are elegant and simple but attractive, and had a great influence on later generations.

The beauty of conciseness. This is clearly illustrated in classical Chinese poems. Chinese lyric poems are famous for their short and concise lines. Like the montage technique used in film shooting, these lines can link separate pictures to achieve a strong effect.

The marble steps with dew turn cold,
Silk soles are wet when night grows old.
She comes in, lowers the crystal screen,
Still gazing at the moon serene.

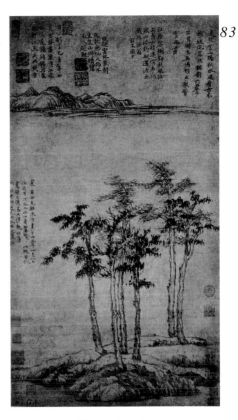

Picture of Six Trees by Ni Zan.

The above poem, titled *Standing Grievously* by Li Bai, a great poet of the Tang Dynasty, describes the sleepless night of a maid of honour in imperial palace in 20 characters. Without the character of complaint, the poem is sad and moving.

Homeward I cast my eyes; long, long the road appears;
My old arms tremble and my sleeves are wet with tears.

83

Meeting you on a horse, I have no means to write.
What can I ask you but to tell them I'm all right?

This four-line poem, titled *On Meeting a Messenger Going to the Capital*, written by Cen Shen, another leading Tang poet, tells of his experience stationed at a remote garrison outpost.

Western poems, by contrast, tend to be longer and wordier. These differences stem from differences in cultural viewpoints and the traditional literary outlooks of the Oriental and Western peoples. Western people attach great importance to the differences between concrete things, and Western literature focuses on reproduction and imitation of things, and emphasizes unique and fantastic plots. Chinese traditional culture focuses on people and exchange of thought, while Chinese literature emphasizes expression of the author's emotions. This is why a poem containing only 20-odd words can be passed down from ancient times and retain its popularity.

Calligraphy is the simplest artistic endeavor, being composed merely of black dots and strokes. The integration, distribution and change of lines create various kinds of charm in a simple, easy, implicit and symbolic artistic means of expression.

Ancient calligraphy critics spoke highly of the functions of expressing beauty and lyrics that simple and concise strokes had, and explained the reasons.

Zhong You, of the late Eastern Han Dynasty, pointed out in one of his articles on calligraphy: "Handwriting is a dividing line composed of dots and strokes, but the beauty expressed by handwriting is produced by persons, and is an outer expression of the aesthetics and ideals of those persons."

In an article titled *On Written Language*, Zhang Huaiguan, of the Tang Dynasty, says, "To express an idea in written language several characters or sentences are needed. But in calligraphy, one character can express the whole soul of the calligrapher. This is the essence of simplicity."

The simplicity and conciseness of calligraphy are its enchanting characteristics.

No complicated tools are needed for calligraphy – just paper, brush, ink stick and ink slab. Also, the characters are for the most part those still used today.

Calligraphy is simple, but it is not easy to master. It is difficult to have a good command of creating a whole calligraphic work which is composed of lines of individual characters. It is very difficult to handle well the relations between the individual characters and the whole work. Calligraphy is like an acrobat's performance of balancing on a monocycle, and the acrobat has to keep his balance through a sixth sense. The handwriting technique is easy to learn, but difficult to master.

The beauty of momentum and rhythm. *The Book of Changes* says, "Energy gathers into visible things." *Zhuangzi*, another famous Taoist book, says, "Human beings live on the gathering of energy. Gathering of energy makes survival of human beings. Human beings die as energy is dispersed."

In works on calligraphy, momentum means the qualities, characters and vitality of calligraphic works. This is one of the basic elements of the beauty of calligraphic works. In his article on momentum of hand writing, Cai Yong of the Eastern Han Dynasty, the earliest calligraphy critic, says, "*Yang* (masuline and positive) and *yin* (feminine and negative) bring calligraphic works vigorous."

Rhythm is different from momentum or energy, and describes a pleasing sound. In the case of handwriting, it means well-arranged dots and strokes forming a harmonious, beautiful, powerful and rhythmical calligraphic work.

The momentum and rhythm of handwriting are like a chemical reaction. Momentum reflects the beauty of the visible structure of characters which change frequently and demonstrate the special technique and ability for expression of the calligrapher, while rhythm reflects the style and the way to illustrate the emotions and feelings of the calligrapher, or the power of understanding, imagination and creation. As Sun Guoting puts it in his famous *Treatise on Calligraphy*: "Great changes take place at the tip of the writing brush" and "rhythm is reflected on the paper" to describe the momentum and rhythm of the handwriting. Rhythm and momentum exist together, are linked together and are the two sides of the same coin, with different designs.

Liu Xizai, a literature and art critic of the Qing Dynasty, spoke highly of the beauty of rhythm and momentum of calligraphy. In his *General Introduction to Literature and Art · General Introduction to Calligraphy*, he says, "Rhythm means expression of emotions and feelings, and momentum means quality and style. Without rhythm and momentum it is not calligraphy." He further talked about the relations between calligraphy and personal accomplishment. He said that rhythm and momentum are expressions of the mind of the calligrapher; otherwise, the calligraphic work is a bad one, just a copy. He emphasized that handwriting should be natural and should reflect the calligrapher himself. Only when the quality of the calligrapher is purified, can the calligrapher create a rhythmic and vigorous calligraphic work.

The beauty of moderation. Moderation is a Confucian theory and a moral standard. According to *The Book of Rites*, moderation can make everything in the world grow. Taoism emphasizes harmony as above everything, and advocates that the people should purify the original features of nature.

In literary and artistic creation, the beauty of moderation means a controlled expression of emotions, and a harmonious and suitable treatment of the relations between the emotions of the artist and the objects and environment around, a harmonious integration of the subject and object.

Sun Guoting was the first to include moderation as one of the aesthetic criteria and guiding principles of calligraphic works. Sun believed that moderation meant the coordination and reunification of the various kinds of organic elements of calligraphy. He confirmed the harmony of calligraphy as reflecting materials while expressing the emotions of the calligrapher. Calligraphic creation is a natural exposure of people's emotions. But such exposure should be mediatory, controlled and harmonious, in order to bring into one line the beauty of nature and the beauty of personality.

Later, many calligraphers made further explanations of the beauty of moderation through their own understanding and practice. They emphasized that calligraphers naturally demonstrate their emotions and feelings through their unrestrained

Part of *Treatise on Calligraphy*, written in cursive script by Sun Guoting. >

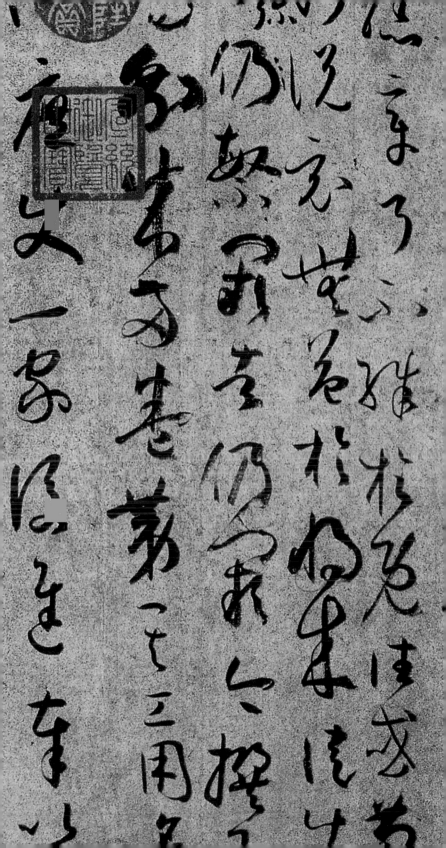

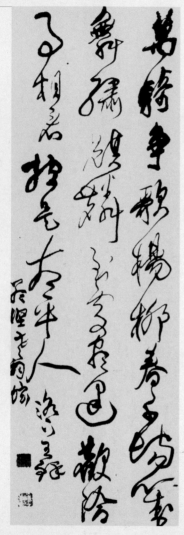

and vigorous handwriting. But if they can control the exposure of their emotions and feelings, their calligraphic works express the beauty of moderation, which can reach even a higher level.

Wang Duo of the late Ming and early Qing Dynasties was a good example in this respect. He made breakthroughs in his handwriting, and sought after novelty, especially in his cursive-script works. In his words, characters are like acrobatic movements in the air. But he controlled his characters in the lines. For example the characters in his *Vertical Scroll of Poem by Gao Shi* on the left page are vigorous and flying, reaching the highest level of the beauty of moderation.

Yang Weizhen of the Yuan Dynasty was not influenced by the long-standing calm and gentle style represented by Zhao Mengfu, and developed the unique style named after him. In *On Donations to Zhenjing Nunnery* (on the bottom of the page) by him in the running script, some characters are big and some small, some are dry and some wet, and some are in the regular script and some in the

Vertical Scroll of a Poem by Gao Shi, written in cursive script by Wang Duo.

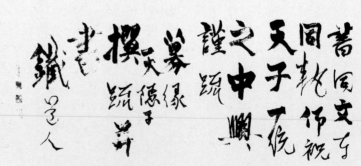

Part of *On Donations to Zhenjing Nunnery*, written in running script by Yang Weizhen.

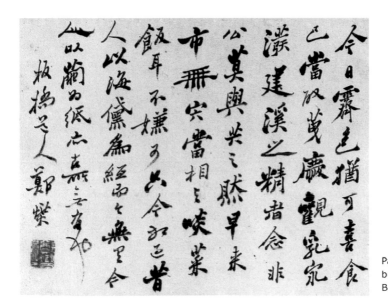

Page from a running-script booklet written by Zheng Banqiao.

cursive script. Also, some characters are in the classical style. The characters are changeable, but integrated. This is an excellent example of the beauty of calligraphic moderation.

Zheng Banqiao of the mid-Qing Dynasty was one of the "eight unusual geniuses of Yangzhou," and was famous for his unique calligraphic style. He was once a county magistrate, but he offended his superior and left his post. He went back to his hometown, and lived by selling his paintings and calligraphic works. He would use several different scripts in one work. Any page from his running-script booklet includes characters written in the official, cursive and running scripts. Some characters are in the styles of Wang Xizhi and Wang Xianzhi, or in the vigorous style which appears on Han steles, or in the free wild cursive script. His handwriting features great changes. However, they are not disordered, but harmonious. Zheng Banqiao was fond of painting bamboo, rocks and orchids. He painted orchids like writing characters, and wrote characters like painting orchids.

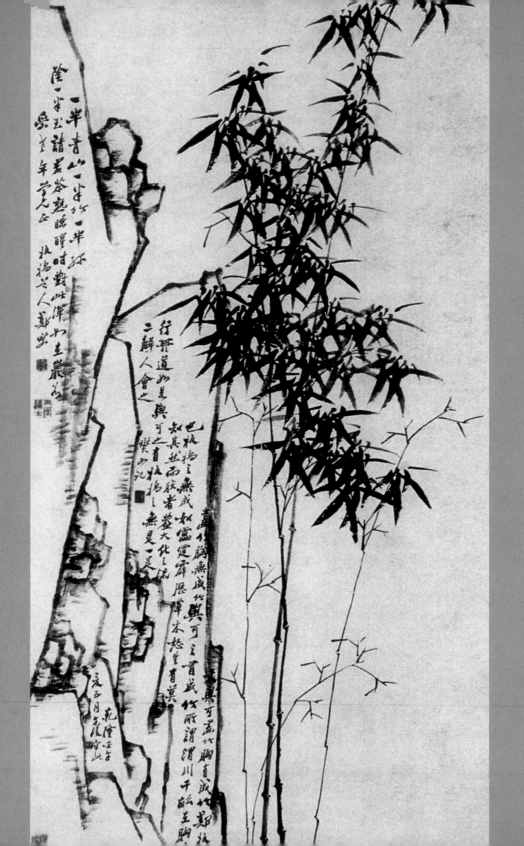

Father and Son:
Leaders of the Times

In the previous chapters we introduce the important functions of Chinese characters and calligraphy. Now we will talk about several key creation trends in the development of Chinese calligraphy in the Jin, Tang, Song and Qing dynasties. Leading these creation trends were calligraphic masters of their periods.

This chapter deals with a father and a son of the Jin Dynasty – Wang Xizhi and Wang Xianzhi. The former was praised as a sage in calligraphy circles.

Wang Xizhi was born into a noble family. His grandfather, father and two brothers were senior officials of the imperial court. His family was a calligraphic family too. Historical records show that of the nearly 100 famous calligraphers of the Jin Dynasty, 20 were of the Wang clan.

In his youth, Wang Xizhi was once a petty official, who gave up official life to live as a hermit and devote himself to calligraphy. He is said to have created nearly 1,000 calligraphic works, but none of the originals have survived. Those we can see today are copies made by calligraphers

92

素為廉吏衣食不充臣愚欲望聖德錄其舊勳矜

其老困復俾一卅俾圖報効志力氣尚此必儻況彼

保養人民臣受國家異恩不敢雷同見事不言干犯

痕嶽臣繇望恐頓首謹言

Part of *Memorial to Emperor Recommending Jizhi*, written in regular script by Zhong You.

of later periods. Of these dozen or so copies, most are in the running and regular scripts, and only one is in the cursive script.

Wang Xizhi learnt calligraphy from his father first, and then from the famous woman calligrapher Madam Wei. In middle age, he crossed the Yangtze River to visit many famous mountains in north China, met many famous calligraphers and examined a lot of stele inscriptions. He studied calligraphic theory and developed a natural and unrestrained new style. For a time, this new style was adopted by the sons and nephews of the famous contemporary calligrapher Yu Yi, much to the latter's chagrin. But before long ,Yu Yi himself admired Wang's new style for its vividness and shiningness.

Wang's new style was a milestone in the history of Chinese calligraphy, praised as a pleasing departure from the old styles of Zhong You and Zhang Zhi of the Eastern Han Dynasty.

Xie An, a grand councilor of the Jin Dynasty, was one of the 41 man of letters who gathered at the Orchid Pavilion (see p. 5). He learnt the cursive script from Wang.

Wang Xianzhi was once an official of the imperial court, of higher rank than his father. Like his father, he was a man of integrity. When Xie An asked him to write an inscrip-

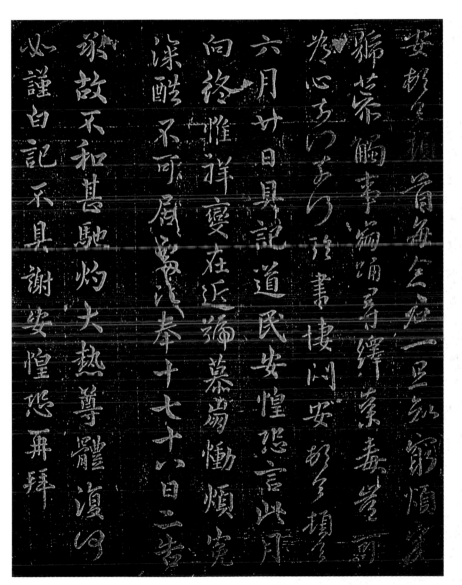

Two notes of running script by Xie An.

tion for a new hall, he refused, because he thought the elegant hall had been built against the will of the people.

A legend has it that in his teens, he told his father that the "zhang cao" cursive script was too restricted, and proposed developing a new style midway between the cursive and running scripts. Later, Wang Xianzhi developed the unique running-cursive script. His *Short Note of Duck-Head Pill* in the running script (see next page) contains 15 characters in two lines. All the characters are natural and smooth, unrestrained and lyrical. In this, he surpassed his father.

According to Sun Guoting's *Treatise on Calligraphy,* one day, Xie An asked Wang Xianzhi, "In comparison with your father's handwriting, what do you think of your own?" Wang answered, "Certainly, my handwriting is better than my father's." "But the critics do not think so," said Xie An. "They do not understand," said Wang Xianzhi. Sun Guoting criticized Wang for this. But this short note shows that his handwriting is in fact better than his father's.

In his *On Calligraphy*, Zhang Huaiguan of the Tang Dynasty said that Wang Xianzhi possessed exceptional talent, and developed a new style different from both the running and cursive scripts. This new style was unrestrained, and became very fashionable.

The Jin Dynasty was racked by internal disturbances and foreign invasions, and many talented people forsook politics for intellectual and philosophical pursuits. Scholars sought to explore life and demanded the liberation of the personality in a revival of the "hundred schools of thought."

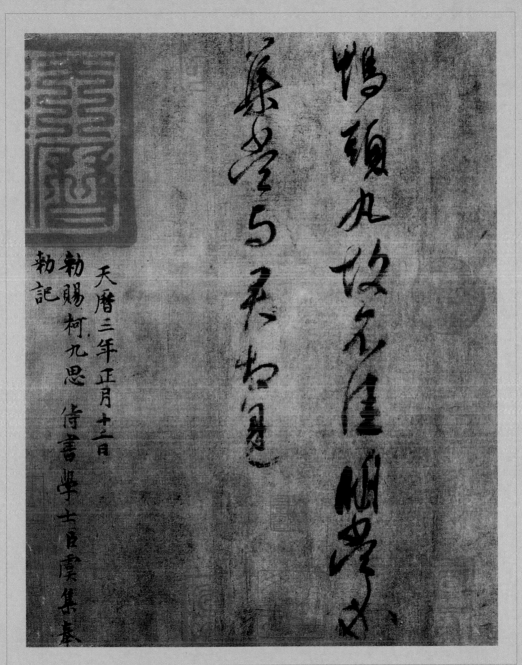

Short Note of Duck-Head Pill, written in running script by Wang Xianzhi.

96

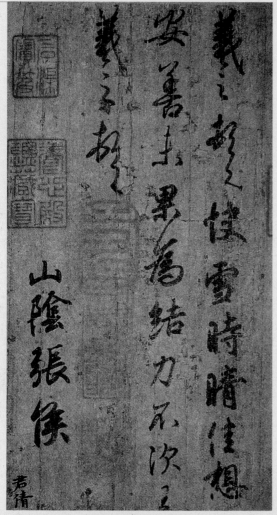

Following this trend, literature and art got rid of the shackles of Confucian doctrine step by step, and sought ways to express emotions and feelings with charm and vigor. Calligraphy, the most concentrated expression of the aesthetic viewpoint of the Jin Dynasty, emphasized the expression of inner emotions and feelings through the patterns of dots and strokes. Calligraphers vied each other to update their handwriting techniques, patterns of characters and structures, thus pushing calligraphic art to its first historical peak.

Short Note of a Sunny Day After a Pleasant Snow, written in running script by Wang Xizhi.

97

Two Masters of the Tang Dynasty

During the Tang Dynasty, calligraphic style changed and developed. In this chapter, we will introduce Chu Suiliang and Yan Zhenqing, the two leaders of the trend in calligraphy trend at that time. In the early years of the Tang Dynasty, there were four famous calligraphers: Ouyang Xun, Yu Shinan, Chu Suiliang and Xue Ji, in order of their ages.

Chu Suiliang (596-658) was once an official of the imperial court, and wrote the draft declaration made by Emperor Taizong when he abdicated in favor of his son. When the new emperor, Gaozong, married Wu Zetian, one of his father's concubines, Chu protested, and was exiled from the capital.

Chu studied the calligraphic styles of Ouyang Xun and Wang Xizhi, and the Han official script. He combined all these into a new type of script, abandoning the "silkworm's head" and "wild goose's tail." His calligraphic style underwent three major changes. The *Preface to Tripitake* is one of his masterpieces. Written in the regular script, the

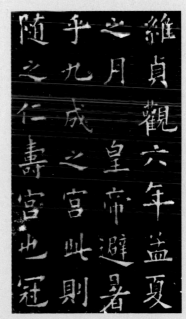

Jiucheng Palace Tablet, written in regular script by Ouyang Xun.

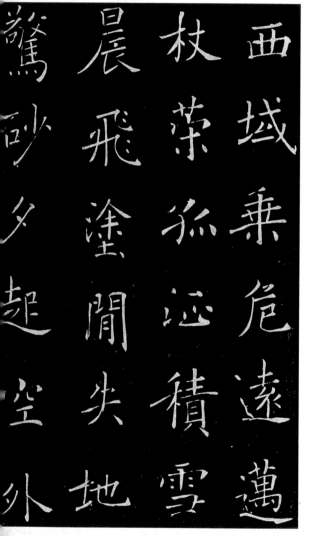

Preface to Tripitaka, written in regular script by Chu Suiliang.

characters are thin and smooth, but powerful. It became fashionable to copy his handwriting, and he himself was praised as a calligraphy master of the Tang Dynasty.

Yan Zhenqing (708-784) was born into an aristocratic family. His grandfather and paternal uncle were calligraphers, and instilled a love of calligraphy into him. Yan passed the highest imperial examination and became an official for a time. His powerful and vigorous handwriting in the regular or running scripts reflect his lofty moral character.

At first, Yan copied Chu's style, and later Wang Xizhi's. He finally developed a powerful, fantastic and beautiful style, which was in harmony with the flourishing culture of the powerful Tang Dynasty. His style has been enthusiastically followed by later generations.

Here we should introduce Liu Gongquan (778-865) who was born 70 years later, and became as famous as Yan, whose style he studied.

Liu Gongquan received encouragement from several emperors, who were his patrons. Liu's characters are powerful, vigorous and smooth, and the strokes extend outward. He is famous for his command of tension and the cohesion of his ink. Like Yan's,

Tablet to Yan Qinli, written in regular script by Yan Zhenqing. >

溫優學

氏其業

為後顏

盎職氏

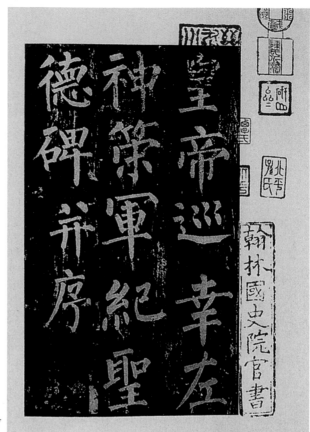

Tablet to Bodyguards of Emperor by Liu Gongquan.

Liu's calligraphy has been copied widely by people of later generations.

Rigor is the most important characteristic of the calligraphers of the Tang Dynasty. The Tang style is quite different from that of the Jin Dynasty, which is elegant, graceful, unrestrained and beautiful, while that of the Tang Dynasty is strict and neat, and easy to learn. From the Tang Dynasty on, calligraphy became an art involving many more people.

Three Masters Focusing on Temperament and Taste

This chapter will introduce three calligraphy masters from the Song Dynasty: Su Shi, Huang Tingjian and Mi Fu, not because they were active in the latter half of the 11th century, and not because they were friends, but because they developed spontaneously a style focusing on the expression of emotion and feelings. Now we introduce them in the order of their ages.

Su Shi had extra talents and knowledge and was an outstanding man of letters, painter and calligrapher. His bold poems constitute his own unique school and were praised highly by the people of his age and the people of later generations. He had a good command of the running and regular scripts. But his political life was turbulent, and he was exiled from the capital several times. Once he was slandered and thrown in prison for 130 days. Saved by the empress dowager and key ministers, he survived but was exiled to Huangzhou in south China.

One spring day in the third year of his life in Huangzhou, he wrote a poem to describe his misery. Then

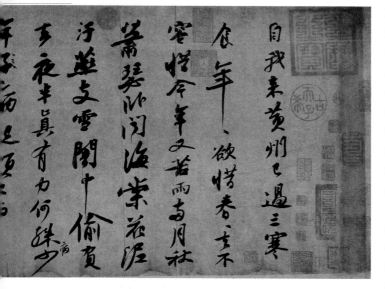

Part of *Scroll of a Poem on the Miserable Life in Huangzhou*, written in running script by Su Shi.

he turned the poem into the famous *Scroll of a Poem on the Miserable Life in Huangzhou*. This poem contains 120 characters in 24 sentences. Many changes in the strokes express a profound artistic conception which matches the depression expressed by the poetic lines.

At the beginning, the characters progress slowly, and show even spaces between them. He uses bent strokes, and oblique parts and lines to express his unquiet heart. In the second character on the second line the last vertical stroke is written like a sharp sword, occupying a large space, which exudes boundless feelings.

What we see here is part of the work. The last sentence means that he wants to go back to the capital city, but there are nine gates to pass through, and he wants to go back to his hometown, but the tombs of his relatives are far away. With different sizes, these characters show strong contrasts, and demonstrate his unstable mind and resentment, and also his perplexity and pessimism. The shapes of the dots and strokes, their strength, speed, falsity and reality, density and looseness, and the ups and downs of their rhythm and changes show the natural harmony of the whole work.

Su Shi left behind him many poems and brief comments on calligraphy. "Innocence and romanticism are my teachers, with imagination and creation, I finish my calligraphic works, free from traditional rules. I write dots and strokes freely,

without any restrictions." He once said that he enjoyed handwriting. It was better for old people to write than to play chess, he said. In the postscript written on a calligraphic work by a friend, he said that calligraphy was a game played with strokes. Su Shi loved painting too. The themes of his paintings are not concrete things, but the water, rocks and hills in his mind or the resentment in his heart.

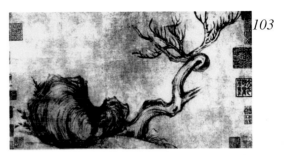

103

Picture of Withered Tree and Strange Rock by Su Shi.

Huang Tingjian was a master of poetry and calligraphy. When he was an official he always had trouble, and was exiled from the capital several times. His calligraphic works are powerful and changeable. The characters in his regular and running scripts extend outward. His handwriting in the wild cursive script is better than that of his teachers. *Scroll to Eminent Monks* (see next page) expresses his unconstrained, straightforward and loquacious nature.

Huang Tingjian emphasized gracefulness in his calligraphy. Like Su Shi, he took calligraphy as a game.

Mi Fu was also good at poetry and calligraphy. He was brave and unyielding. His personality shows in his unrestrained, light and natural running and cursive script handwriting. His *Collection of Tiaoxi Brook Poems* in the running script is a good example of this.

Mi Fu's articles on calligraphy, like his calligraphic works, focus on graceful and romantic touches. By these standards, he assessed the calligraphic works of his predecessors. He even criticized Yan Zhenqing, a calligrapher of the mid-Tang Dynasty, who opened a new chapter for the development of calligraphy, saying that Yan's regular script handwriting was too plain. Like Su Shi and Huang Tingjian, he believed that calligraphy was a game, saying, "Calligraphy is a game, so it is unnecessary to consider the characters as beautiful or ugly. It is enough if you are satisfied with your work. After you put down the brush, the game is over."

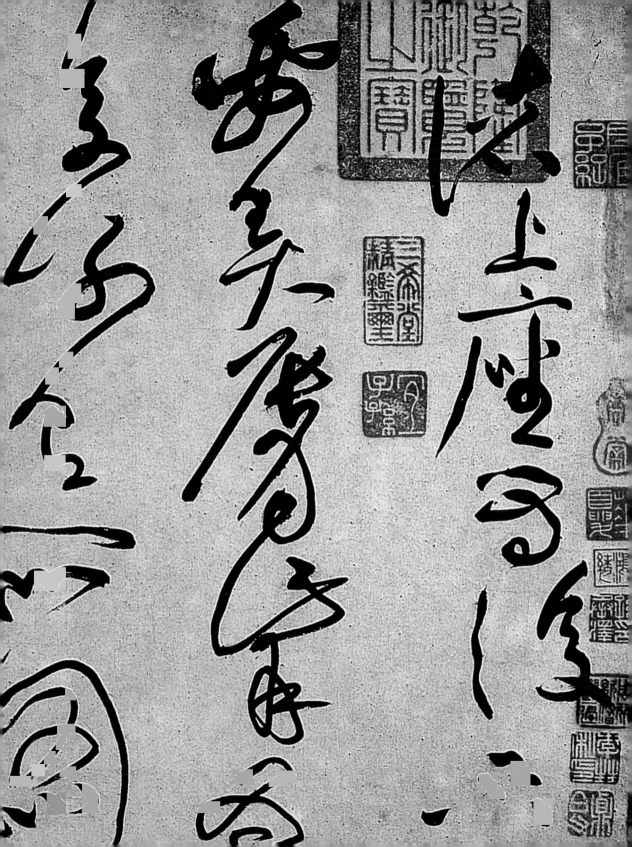

< *Scroll to Eminent Monks,* written in wild cursive
script by Huang Tingjian.

Three Masters Focusing on Temperament and Taste

These three calligraphy masters from the Song Dynasty were influenced by the
prevailing cultural trends and aesthetic viewpoints. The Song Dynasty was
influenced by the developed culture of the Tang Dynasty, but it met internal and
external unrest. The men of letters had less aspirations and progressive enthusiasm
than those of the Tang Dynasty. When they found it difficult to realize their high
ambitions, they devoted themselves to poetry, calligraphy and other artistic activities
exclusively. Opposite to the vigorous and forceful style of the Tang Dynasty, the
poetry of the Song Dynasty sought a deep and cold resonance. Tang paintings have
landscape, flowers, birds and natural scenes as the background, and beautiful women,
cows and horses playing the main roles. But the landscape paintings of the Song
Dynasty have natural scenes as the main objects.

Therefore, the people of the Song Dynasty liked the running-script calligraphy, a
script between the regular and the cursive scripts – not rigorous like the regular
script, and easier to learn and recognize than the cursive script. The running script
is convenient for the calligrapher to use his brush, and makes it easy for him to

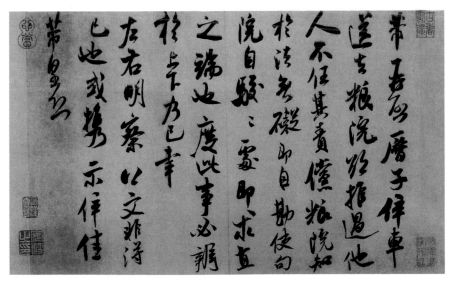

Part of *Scroll of Tiaoxi Brook Poems* in running script by Mi Fu.

express his peaceful, simple and leisurely mind, and to realize his aspiration to be happy through calligraphy.

The sentiments and interests the Song calligraphers sought are similar to but different from the gracefulness cherished by the Jin calligraphers. Both emphasized the beauty of the image of the objects and the beauty of the interest and charm of calligraphy. But the gracefulness cherished by the Jin masters has a narrow connotation, merely having a peaceful, plain and quiet tone. While playing such an artistic game, the Song calligraphers got rid of all kinds of shackles and pressures, and created works in a powerful and unconstrained style. They reached the best understanding of the poetry and handwriting, and expressed them in the best way. So the calligraphers took their counterparts from the Jin Dynasty as their teachers but they outstripped their counterparts in purport and techniques. This is obvious from a comparison of the handwriting in the running and cursive scripts by the Song calligraphers with those of the Jin calligraphers.

Contemporary Reforms and Modern Brilliance

In the mid-19th century, calligraphy experienced a great change. In the early Qing Dynasty, two emperors loved the regular but soft style of Zhao Mengfu of the Yuan Dynasty and Dong Qichang of the Ming Dynasty, and suggested encouraging learners to imitate these styles. Thus, a trend of seeking a graceful but monotonous and dull style came into fashion.

Furthermore, ancient bronze and stone inscr-iptions were rediscovered at this time, and men of letters and scholars found new ways to express their emotions and feelings when began to study them. Some calligraphers copied the ancient characters found on these bronze and stone inscriptions. The more they practiced, the more conscious they became of the importance of the changes of shapes of characters and handwriting style in demonstrating their aesthetic interests and creative abilities. Under such an influence, imitations of ancient calligraphic styles emerged.

Such a reform trend continued into the late 19th century.

Kang Youwei, a famous figure in modern Chinese history, recommended copying the style of the tablet script of the stone inscriptions from the Northern Wei Dynasty. He bought a lot of copybooks of rubbings of stone inscriptions, and studied them. In 1899, he wrote a 60,000-word book on calligraphy, in an attempt to modernize calligraphy. In this, he was successful, although his attempt at political reform failed.

The tablet script Kang recommended was the script used for inscriptions on tombstones and stone images from the Northern Wei Dynasty (386-534) found in Henan and Shandong provinces. The tablet script belongs to the regular script genre, and most stone inscriptions were written or carved by less-educated rural people. The patterns are crude, and some characters contain erroneous strokes. So for quite a long period of time, this script was ignored by calligraphers. But Kang thought that this script demonstrated the beauty of strength and strangeness.

In the first chapter of his book, Kang explained the reasons for a change in the calligraphic style, alongside his views on political reform. He said that, like politics, calligraphy needed a change or a reform. Inspired by his view, many calligraphers dared to resist the soft, dull and monotonous calligraphic styles advocated by emperors and institutions of higher learning. Students of calligraphy studied and copied the Northern Wei Dynasty inscriptions. The movement spread rapidly.

At the same time, scholars started paying great attention to the seal script on bronze objects and tortoise shells, the official script from ancient tablets, and the old-style characters on bamboo or wooden strips, stones, tile-ends and silk fabrics. Kang himself combined the stone script with the Tang and Song styles made by Ouyang Xun, Su Shi and Huang Tingjian, and developed his own Kang style, featuring a close and powerful pattern.

Kang Youwei and other calligraphers of his time followed a road of reform in which all kinds of tablet inscription and scroll styles supplemented each other. But each person had his own style of practice and creation. Following are stories of some of them.

Yang Shoujing, a bronze and stone inscription scholar and calligrapher of the late Qing Dynasty, said the tablet inscriptions and scroll styles can integrated into

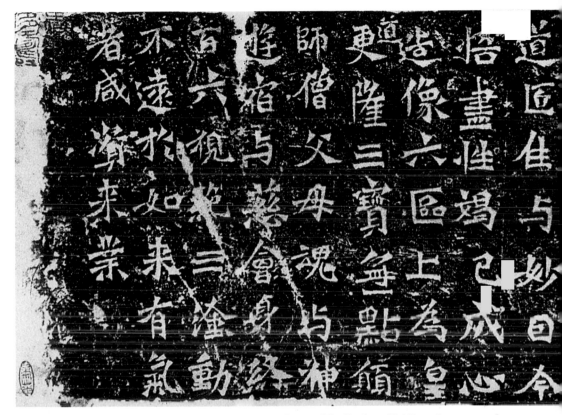

Tablet to Daojiang Statue of the Northern Wei Dynasty.

a perfect thing, and they were not perfect if separated. He always moved his brush slowly, thus displaying special vigor in characters.

In modern times, Lu Weizhao, a professor at the Zhejiang Academy of Fine Arts, is outstanding in poetry, calligraphy and painting, and boasts a profound knowledge of history, philosophy and music. In calligraphy, he has developed a new style between the seal and official scripts. Also, he uses the aesthetic principles of the structures of

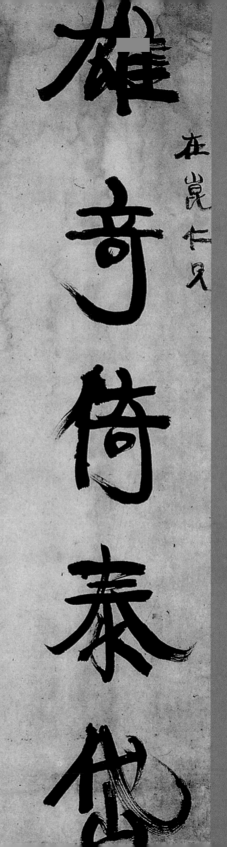

Antithetical couplets written in running script by Kang Youwei.

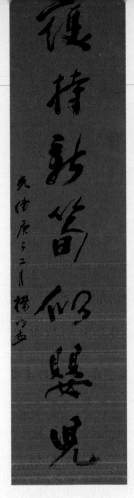

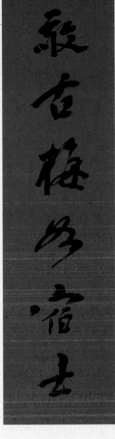

Antithetical couplets written in running script by Yang Shoujing.

A vertical couplets written in seal script by Lu Weizhao.

characters of the cursive and running scripts and deforms or changes the patterns of characters, rebelling against the principle of the even, balanced and symmetrical patterns of characters. Such a script keeps the features of bronze and stone inscriptions, but also adds a lovely running style. In this style, the left and right parts of a seal-script character are parted, one being longer and the other shorter. The space between the horizontal lines is narrow, while the space between the vertical lines is wide. In this way, the whole work is quite different from those done in the ancient seal script.

One work by Wu Shangjie in the style of the Cuanbaozi Tablet of the Jin Dynasty, a style between the official and

regular scripts, does not demonstrate the gracefulness of the stone carving of the southern tablet but is as simple, precipitous and clumsy as that of 1,500 years ago. He has added the features of the cursive script to it, to produce a charming effect.

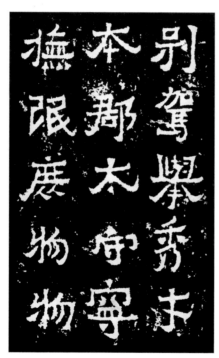

Part of *Cuanbaozi Tablet*, unearthed in Yunnan Province in 1778. So it is called a southern tablet.

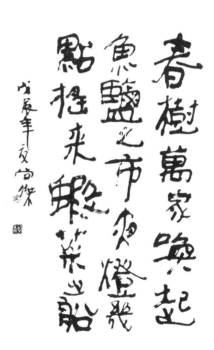

Antithetical couplets written in tablet script by Wu Shangjie.

※　　　※　　　※

The changes in calligraphy in the four dynasties mentioned above show an evolutionary track of Chinese calligraphy. The calligraphic style of the Jin Dynasty, which held gracefulness in high esteem, was reversed by that of the Tang Dynasty which held rigorous rules. The style of the Song Dynasty reversed that of the Tang Dynasty and held gracefuless, but this does not mean that it simply went back to the style of the Jin Dynasty; it absorbed the essence of both and focused on the expression of emotions and feelings.

The Qing Dynasty ended in 1911. In the half century which followed, clashes between warlords lasted for 20 years, to be followed by the Japanese invasion. In February 1998, the China Federation of Literary and Art Circles and the Chinese Calligraphers' Association held an exhibition of works by the deceased famous calligraphers of the troubled period of the late Qing Dynasty and early 20th century at the National Art Gallery in Beijing. The exhibition offered us a chance to view original works by some 100 famous calligraphers of the older generation. Some of them were thinkers or politicians, and some were scholars or artists, including Kang Youwei, Liang Qichao, Sun Yat-sen, Mao Zedong, Zhou Enlai, Guo Muruo, Wu Changshuo, Shen Zengzhi, Li Ruiqing, Yu Youren, Qi Baishi, Zhang Daqian, Xu Beihong, Huang Binhong, Shen Yinmo, Sha Menghai, Pan Tianshou and Lin Sanzhi. Done in various script styles, these calligraphic works demonstrate unique techniques and personalities. Some developed their own masterly techniques, while others combined their own style with those of others.

Since the founding of New China in 1949, and especially in the two decades after China introduced the reform and opening-up policies, Chinese calligraphy has entered a flourishing period seldom seen before. The national economy has developed steadily, and the living standards of the people and their cultural level have improved greatly. Calligraphy and painting have become parts of the cultural activities of the Chinese people, breaking the ages-old tradition in which only men of letters occupied themselves with calligraphy. Calligraphy courses have been

opened in middle and primary schools. Also, calligraphy is taught in colleges and universities. Localities run calligraphy classes for retired people. Many books, newspapers and magazines, specialize in the study of calligraphy, and local TV stations hold lectures on calligraphy. The Chinese Calligraphers' Association was established in 1981, with branches in all provinces, autonomous regions and municipalities. The association and its branches regularly sponsor calligraphic exhibitions, domestic and international academic symposiums and other activities.

Remarkable progress has been achieved in the field of theory, too. Large amounts of relics connected with calligraphy have been discovered, such as inscriptions on tortoise shells, bamboo strips and silk fabrics. Many reference books and teaching materials have been published. Also, many calligraphic researchers have the chance to be enlightened by the new research fields and new achievements gained in research in other fields such as modern sciences, philosophy, aesthetics and psychology, and in other arts, including painting, music, dance, poetry, novels, handicrafts and gardening. Today, calligraphic scripts have become varied, so as the branches. So we are proud to say that Chinese calligraphy has entered the most brilliant period of its history.

Chinese Calligraphy Spreads Worldwide

In the second or third century, Chinese calligraphy was introduced to the Korean peninsula, and flourished during the seventh century. Many calligraphers emerged, and a variety of calligraphic scripts appeared. These scripts can be found on steles, pagodas, bronze bells and Buddhist scriptures.

In the eighth century, Kim Shaing became Korea's first famous calligrapher. He learned Chinese calligraphy when he was a child, and still practiced it when he was in his 80s. He had a good command of both the running and official scripts. He could be compared with Wang Xizhi in running and running-cursive handwriting. None of his original works survive, but his characters were included in three kinds of copybooks of tablet inscriptions, the earliest intact calligraphic work found on the Korean peninsula today. On the following page is his tablet running-script handwriting of *Poem on Lushan Waterfall*, a poem by Li Bai of the Tang Dynasty.

Korean calligraphers have long admired the Chinese

works of Ouyang Xun and Yan Zhenqing of the Tang Dynasty, Su Shi and Huang Tingjian of the Song Dynasty, Dong Qichang of the Ming Dynasty and Weng Fanggang of the Qing Dynasty, and especially the graceful handwriting in the running or regular script by Zhao Mengfu of the Yuan Dynasty. In the 14th century, Zhao-style characters appeared in official documents and in articles by scholars in Korea.

In the seventh century, Chinese calligraphy also reached Japan. In 615, a Japanese prince made a copy of *Explanation of the Lotus Sutra* with a soft writing brush, the earliest handwriting in Japan extant today. The characters are smooth and harmonious, and represent a script of the Jin Dynasty.

In the eighth century, Sino-Japanese cultural exchanges developed, and Japan sent many envoys, students and monks to China, who lived in China

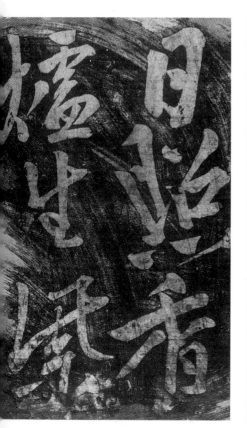

Part of *Poem on Lushan Waterfalls*, written in running script by Kim Shaing of Korea.

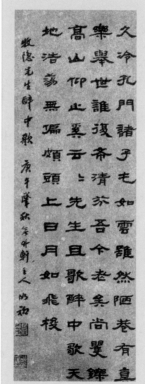

Drunken Song, written in official script by Kim Yeng Hyun of the ROK.

for long periods of time. When they went back to their own country, they took with them many calligraphic works, especially works by Wang Xizhi and Wang Xianzhi of the Jin Dynasty, and Ouyang Xun and Yan Zhenqing of the Tang Dynasty. Japanese Empress

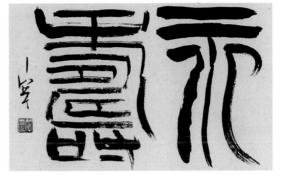

117

Example of the Japanese "Less-word style".

Mitsuaki studied the style of Wang Xizhi, and became a renowned calligrapher in her own right. In the ensuing centuries, works by Su Shi, Huang Tingjian, Zhang Jizhi, Zhao Mengfu, Zhu Yunming, Wen Zhengming, Dong Qichang, Zhang Ruitu, Wang Duo and Zhao Zhiqian of the Song, Yuan, Ming and Qing dynasties were introduced to Japan. In the late 19th century, Yang Shoujing, who was an envoy from the Qing Dynasty to Japan and an expert on bronze and stone inscriptions, took a number of copybooks of stone inscriptions of the Northern Wei Dynasty to Japan, which influenced the style of Japanese calligraphy.

At the same time, Japanese calligraphers created their own works and styles by combining Chinese styles with their own aesthetics and written language. Since then, Japanese calligraphy has been a new branch, different from the Chinese art. In the ninth century, the kana script appeared in Japan. Most of the letters used in the Japanese script are borrowed from the basic structural parts of Chinese characters; the type used in the printing script (or the regular script) is called katakana, and the type used in

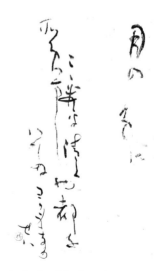

Example of the Japanese "Compromising style".

the writing script with swift and flowing strokes is called hiragana. This departed from the established mode of using Chinese characters only, and led to the exploration of new styles.

Following World War II, a "vanguard" calligraphic style appeared in Japan, as a result of the influence of Western fine art, especially abstract painting.

Chinese calligraphy has also been warmly welcomed by and used in their creations of Western artists, especial painters and sculptors.

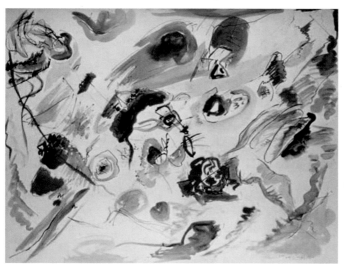

The Earliest Abstract Watercolor Painting by W. Kandinsky.

In the early 20th century, W. Kandinsky, a German painter and aesthetic theorist, developed the abstract painting school. He and his counterparts sought abstract form, and used dots, lines, surfaces and colors to create beautiful pictures and express their feelings. They believed such art shared many similarities with Chinese calligraphy, and they borrowed many ideas from Chinese calligraphy. *The Earliest Abstract Watercolor Painting*, a famous work by Kandinsky, is composed of lumps and lines, without a center, like a mess of colors and memory of images. But he demonstrates his understanding of the things in his picture. The lumps and

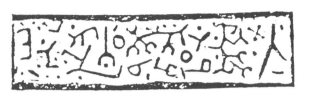

119

lines bring the viewer many associations, like a lot of people in a hurry or talking at a rural fair. Some lines are like mountains, and the colors seem to extend beyond the picture frame. The strokes and lines in the picture are powerful, loose, coordinated and moving, like a Chinese calligraphic work written in the wild cursive script.

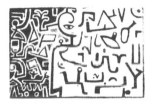

Oil paintings by Paul Klee.

Paul Klee, a Swiss painter, expresses his personal feelings with pattern, colors and space in his paintings. Also he is good at using musical forms. In these two oil paintings of his, the geometric figures are reminiscent of the signs carved on ancient Chinese pottery before the development of Chinese written characters.

Sir Herbert Read, a British poet and critic, says in his work on the history of modern painting that abstract expression is an extended expression of Chinese calligraphy.

Henri Matisse, leader of the French Impressionist movement and praised as one of the two most important

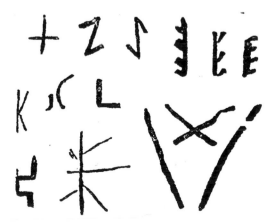

Signs on ancient pottery before the emergence of Chinese characters.

painters in the 20th century together with Picasso, paid great attention to the simplicity and flow of lines, the inspiration for which he claimed to have got Chinese calligraphy.

Joan Miró, a Spanish painter and sculptor, is famous for his concise but imaginative paintings. He tried his best to make his works poetic and use the intellect of the 20th century to express the nature like a child or a person from a primitive society. Someone commented that the space in his painting is similar to that appears in Oriental calligraphic works. His *Self-Portrait* was completed with himself standing in front of a mirror.

Special classes on Chinese calligraphy have been opened in many European academies of fine arts. The design and shaping of new artistic trends worldwide, and the binding and illustration of books and periodicals have been influenced by Chinese calligraphy.

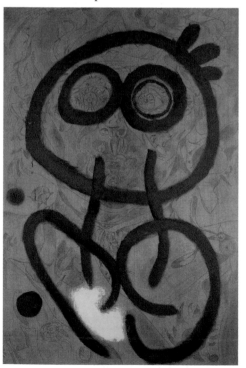

Self-Portrait by Spanish Joan Miró.

Also, China has drawn upon the experiences of others, especially since it implemented the reform and opening-up policies. Inspired by Western abstract art and Japanese calligraphic scripts, Chinese calligraphers have developed a "modern calligraphic style," which features a strong contrast between the thickness and thinness of strokes, heavy and light ink, closeness and looseness of characters or lines, and the dryness and wetness of ink. Also, this style uses different colors. The character patterns have changed and become exaggerated, too. Some pictographic characters are written in their real shapes. For instance in the calligraphic work *Moon and Boat*, the character 月 (moon) in the seal script is like a crescent, while the character 舟 (boat) looks

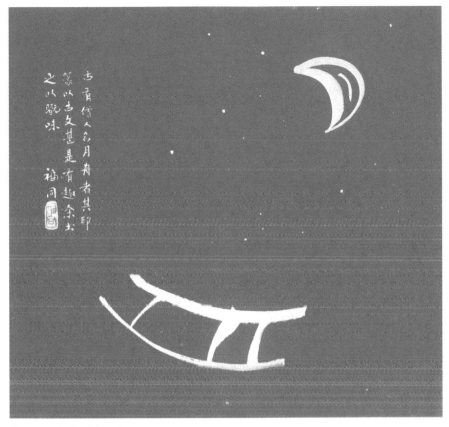

Moon and Boat by Xu Futong.

like a real boat in the water. The white dots around them look like stars in the sky. Both characters are written not according to the order of strokes and the traditional rules, but in a new style to attract the eye of the viewer.

Some modern Chinese calligraphers have boldly learnt from the Western and Japanese abstract schools, and make dots, lines and lumps in different colors on the paper, without forming them into characters.

Some people have praised such attempts as breakthroughs in traditional Chinese calligraphy and the future orientation of this art, while others have criticized it as departing too much from the calligraphic rules,

Swimming by Yang Lin.

especially the works without any actual Chinese characters. There seems to be no prospect of a conclusion being reached to this debate any time soon. Maybe there is no need for any conclusion at all. The really creative attempts will become a new trend and join the long skein of development of Chinese calligraphy; attempts without any vitality will die out.

Here, I want to express my opinions on the similarities and differences between Chinese calligraphy and Western abstract art.

Chinese calligraphy is an abstract art in itself to some extent. Its abstract features are illustrated in the fact that it absorbs the beautiful aspects of a thing, its neatness, differences in length, balance, symmetry, closeness and looseness, stillness and motion, changes and harmony. Also, Chinese calligraphy can be imitated and reshaped. All these aspects are similar to the art of Western abstract painting which creates pictures different from the real things.

But I should point out that the two are different in nature. Chinese calligraphy does not imitate other things, only the characters. With Chinese characters as carriers, the calligraphers try to create characters to be recognized by the viewer, which is quite different from the intention of Western abstract paintings.

Western abstract artists do not use any thing or any language as their artistic carrier to arrange lines and colors. They seek unique forms, and they try to create quite different paintings. They pay attention to the fantastic structures and video effects of their paintings, especially the quality and coloring. They try to express their rich imagination and spirit of rebellion against traditions and formulas. Without an artistic carrier and without the restrictions of rules and formulas, they rack their brains for creativity and do their best to produce mysterious and thought-provoking paintings; the more attractive and irritating their paintings are, the better. So they use utensils in order to create an artistic dreamland which neither they nor others have ever seen before.

Willem de Kooning, a French painter, created calligraphic works similar to the Chinese wild cursive script. But he used colors instead of ink. It is said that his paintings show how he followed the artistic principle of exploring a pioneering way of expression in calligraphic works by means of calligraphic dynamics.

Based on Chinese characters, calligraphy is restricted by rules such as the structure of the characters. All characters are written by way of fixed rules, patterns and order of strokes. Calligraphers can create a graceful work unhurriedly, and with a well-thought-out plan. Their works are novel in style and with many changes, but the characters they create according to the familiar rules are readable. So the viewer feels that the works are attractive, and are receptive to their inspiration and tease.

Chinese calligraphers are used to

Wind by Yang Lin.

expressing their feelings through the patterns of the characters. Sun Guoting of the Tang Dynasty says in his *Treatise of Calligraphy* that people write calligraphic works to express what is in their minds, and the form of calligraphy can be in various styles, which follow the principles of structural beauty and nature, and the rules of the objective world. The feelings displayed through calligraphic works are similar to those expressed through poems in *The Book of Songs* and the *Elegies of Chu*. In short, Chinese calligraphy reflects real, graceful and natural feelings of an inner world of calligraphers, not an unconscious sentiment. It aims to inspire people, and soothe pained hearts, not to challenge or stimulate sense organs.

■ Appendix 1

The Dynasties Mentioned in This Book

125

Shang Dynasty	c. 1600—1046 B.C.
Early Shang Dynasty	c. 1600—1300 B.C.
Later Shang Dynasty	1300—1046 B.C.
Zhou Dynasty	1046—256 B.C.
Spring and Autumn Period	770—476 B.C.
Warring States Period	475—221 B.C.
Qin Dynasty	221—206 B.C.
Han Dynasty	206 B.C.—A.D. 220
Western Han Dynasty	206 B.C.—A.D. 25
Eastern Han Dynasty	25—220
Wei Dynasty	220—265
Jin Dynasty	265—420
Southern and Northern Dynasties	420—589
Tang Dynasty	618—907
Five Dynasties	907—960
Song Dynasty	960—1279
Yuan Dynasty	1271—1368
Ming Dynasty	1368—1644
Qing Dynasty	1644—1911

■ Appendix 2:

List of Main Illustrations

p2 A traditional sitting room of a scholar.

p3 A running-style calligraphic work by Pan Boying on a fan covering.
A pair of Spring Festival couplets and New Year pictures on the main gate of a house.

p4 The gate-tower of the Shanhai Pass and the horizontal plaque.

p5 The text of the *Buddhist Diamond Sutra in the Sutra Stone Valley*.

p6,7,8 *Preface for the "Collection of Orchid Pavilion Poems"*, written by Wang Xizhi.

p9 A picture of Lu Xun.
A running-script letter by Lu Xun.

p10 *Four Models of Calligraphy of Classic Poems*, by Zhang Xu.

p11 A wash painting, *Shrimps,* by Qi Baishi.

p16 *Buddhist Sutra* by Liu Yong.

p18 Square scroll by Bada Shanren.

p19 A pair of couplets by Yu Youren.

p20 Seal-script characters by Wu Changshuo.

p21 *Camellia* by Wu Changshuo.
Book of Models by Qian Shoutie.

p23 Designs on ancient pottery.

p24 Picture of Cang Jie.
Inscriptions on oracle shells.

p25 A short note written by Wang Yirong.

p26,27 Some inscriptions on tortoise shells illustrated on Liu E's book, *Tortoise Shells Preserved by Tie Yun*.

p28 Maogong three-legged cauldron and the inscriptions engraved on its base.

p29 Sword of Prince Wu of the Spring and Autumn Period.

p30 *Taishan Mountain Inscription* in the seal script by Li Si.

p31 Ancient official-script characters written on silk.

p32 Ancient official-script characters on bamboo strips.

p33 *Shichen Tablet*.

p34 *Ode on Sending Out the Troops* in "zhang cao" cursive script.

p35 *Baiyuan Scroll* in the running cursive hand by Wang Xun.

p42 Patterns on painted pottery unearthed in Banpo Village, Xi'an.

p46 *Book of Models* by Qian Dian.

p52 *Prose on the Goddess of the Luo River*, written by Zhu Yunming.
Preface to the Pavillion of Prince Teng, written by Wen Zhengming.

p55 *Mid-Autumn Scroll*, written by Wang Xianzhi.

p56,57 The Summer Palace in Beijing.

p58 *Du Fu's Ode to He Lanxian*, written by Huang Tingjian.

p61 Image of Yue Fei and part of *Prayer for the Dead on an Ancient Battlefield*.

p62 *Mottoes by Xie Changyuan,* written by Wen Tianxiang.

p63 Part of *Ode to Congma (a Kind of house) of His Excellency Deng,* written by Zhang Ruitu.

p67 *Tablet to Zhang Qian*.
Tablet to Cao Quan.

p68 *A Shot Note of Chive Flower*, written by Yang Ningshi.

p69 *A Shot Note of Summer Heat*, written by Yang Ningshi.

p70 A Brief Note written by Wang Anshi.

p72 *A Letter Informing Recovery of Relatives and Friends*, written by Lu Ji.

p73 *Tablet to Prince Shengxian*, written by Wu Zetian.

p74 *Record of Three Tombs*, written by Li Yangbing.

127

Chinese Calligraphy Cultural China Series